PROFESSIONAL SECRETS OF
NUDE AND BEAUTY PHOTOGRAPHY

TECHNIQUES AND IMAGES IN BLACK & WHITE

Bill Lemon

AMHERST MEDIA, INC. ■ BUFFALO, NY

ACKNOWLEDGEMENTS

I would like to thank all those people who pushed me to do the second book. To note a few: my family, who showed me a great response to the first book (*Black & White Model Photography*), and to all the people I've met through that book, who encouraged me to continue with this style of work. The input of the models who helped me with this book was just fantastic. To name a few: Dale, Nicole, Kirsten, Michelle and Lindsey.

I would also like to thank Sheldon Steinburg at the Elegant Bowl in Cotati, CA for the use of his bathtub warehouse. Thanks to the staff at Amherst Media for helping me put this book together.

A big thanks to the Zone Plus lab on Rohnert Park, CA for all the help in printing the images for this book—thanks DJ! I cannot forget to mention people like Art Ketchum, Brian Ratty, Mike Jarboe, and Spencer Colquhoun. Thanks to Mike Harvey for the use of the White Lightning strobes that were used for 90% of the studio images taken for this book. Thanks also to Bill Holshevnikoff and Seeg/Callister Lab in Novato, California.

Cover: Backdrop courtesy of Backdrop Outlet, Chicago, Illinois.

Contact: www.BillLemon.com

Published by:
Amherst Media, Inc.
P.O. Box 586
Buffalo, N.Y. 14226
Fax: 716-874-4508
www.AmherstMedia.com

Publisher: Craig Alesse
Senior Editor/Production Manager: Michelle Perkins
Assistant Editor: Barbara A. Lynch-Johnt

ISBN: 1-58428-044-1
Library of Congress Card Catalog Number: 00-132620

Printed in the United States of America.
10 9 8 7 6 5 4 3 2 1

TABLE OF CONTENTS

PREFACE

Often we poke fun at certain primitive people who run away from the camera because they are afraid that the photographer will steal a piece of their souls. But they can be quite right. A good image *can* take away a piece of the human essence. The photographer can carry this essence back to the studio to examine it more closely; sometimes simply to preserve it, sometimes to share it with others. In return, and this is usually overlooked, creative photographers leave a piece of their own essence in the image as well.

Model photography is a collaboration, a transaction, and an inspiration between photographer and model. This collaboration reveals the personalities of both photographer and model. If the two establish a rapport, the photograph will be a success.

I did not meet Bill Lemon until two years ago, after I had reviewed his first book, *Black & White Model Photography*, which I found to be inspiring and informational. Over time, I have been fortunate to get to know not only his photography, but also Bill Lemon as a person—a person who brings passion, purpose and professionalism to his craft. While other photographers may find it easy to turn off their reactions to their models and create images that are superficial and glossy, Bill Lemon creates images of his models that reflect his own personality as well. He is a master craftsman. More than just good camera technique, Bill Lemon's work displays fresh ideas that enhance the beauty of the models he works with.

When reviewing the images in this book, I see vision and uniqueness, which makes his work truly meaningful. Bill uses the black & white medium to create balance and beauty, interest and fascination. It's more than posing, more than light, and more than glamour photography. Bill Lemon's work reflects his soul.

—Brian D. Ratty
Photo-Seminars.com

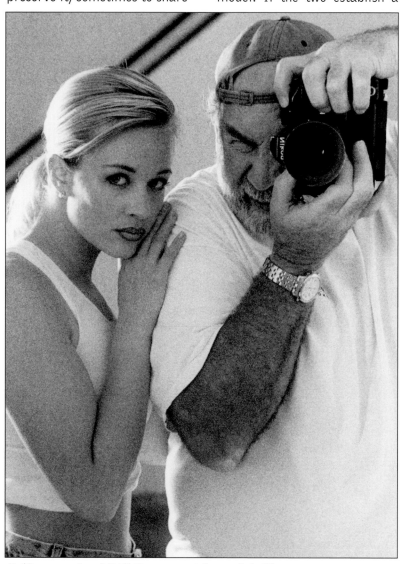

Self-portrait of Bill Lemon with model, Shannon.

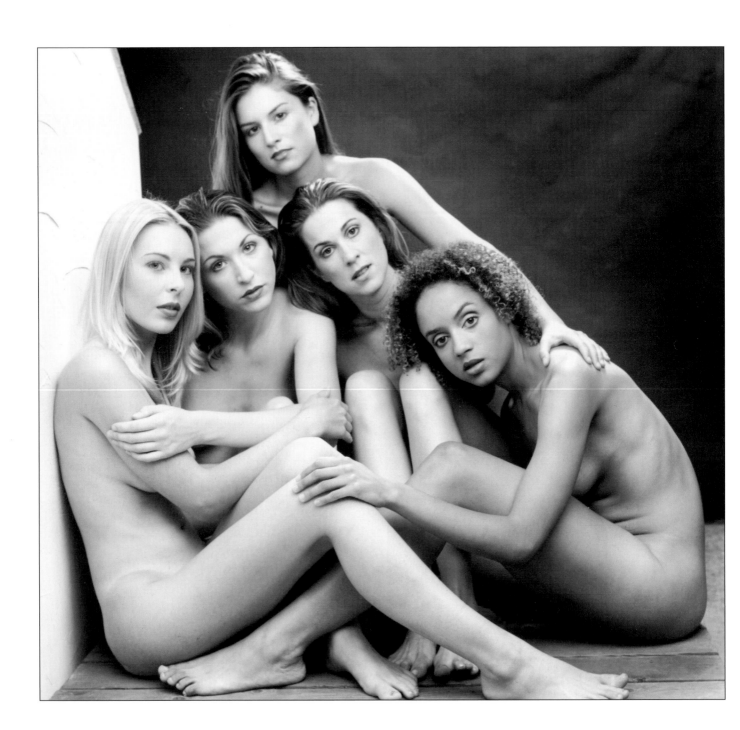

INSPIRATION

↔ INSPIRATION

This image of five nude models was based on a famous image of five supermodels shot by Herb Ritts. I liked the image and decided to try to recreate the look he achieved using my own models. I wanted models with great bodies and beautiful faces, and selected from the models I had worked with before (you'll see more of their images throughout this book).

↔ SETTING

The models were posed at the base of the staircase in my studio (you can see the white stucco wall on the left side of the image). I posed the group on a low platform (an old tabletop). The backdrop was black seamless paper.

↔ LIGHTING

Two lights were used for this photograph. The first was a hair light positioned over the grouping of models. This accented their hair and provided separation from the background (this is especially evident on the left shoulder of the brunette model). The main-light was a large softbox placed above the camera on the lens axis. Since I was shooting from a very low camera angle (close to the floor), this meant that the light from the softbox hit the models pretty much straight on, for a soft and even effect.

↔ POSING

Working with a group of models was made slightly easier due to the fact that most of the

CAMERA:
Pentax 6x7

LENS:
105mm, f/2.4

FILM:
Kodak Plus X
at ISO 100

women I used in this shoot were experienced models, accustomed to taking direction, comfortable with nude photography, and used to holding poses. Still, five models means a lot of elements to coordinate. I showed the models the image before the shoot so they would know what I was going for and needed from them. Having this original image to serve as a guide was helpful, but I still shot about sixty frames before I was sure I had an image with every girl correctly posed, and every girl with the right expression.

Models: Summer, Nicole, Lindsay, Sheila, and Loriana

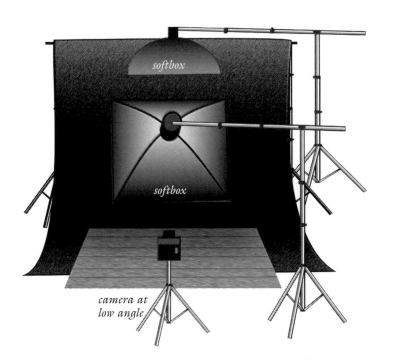

softbox

softbox

camera at low angle

CLOTHING SELECTION

⇥ LOCATION

This image was taken at the site of an old barn. This was one of my favorite locations to do nude photography until it was torn down not too long ago. The site was secluded and I loved the way the rugged setting contrasted with the femininity of the models. There are still several pieces of farm equipment on the site, and I continue to use those. For this photograph, the model posed standing on the tire of a gasoline tanker. Posing her against this large metal surface provided wonderful detail and texture in the background of the image.

⇥ LIGHTING

This image was shot in the afternoon under strong sunlight. This isn't traditionally considered the best time of day for portrait lighting, but since time constraints and models' obligations often don't allow me the luxury of scheduling sessions precisely when I'd like, I've learned to use the light I have to make the image work. Here, with the sun strongly overhead, I had the model tilt her face up and close her eyes, ensuring that her face (and especially her eyes) would be fully illuminated.

⇥ POSING

The pose here is extremely flattering (partially the result of working with an experienced model). The model's left knee is drawn up softly, crossing delicately over her right leg and creating a soft curve in her ankle. Dropping her left hip and raising her left arm creates an elongated appearance throughout her body, which runs as a gentle S-curve through the frame. Her extended right arm, with the fingers gently spread, adds a sense of balance to the composition. The final touch was the breeze that lightly tossed her blonde hair, whisking it away from her face and lending a natural character and sense of movement to the image.

CAMERA:
Pentax 6x7

LENS:
165mm, f/2.8

FILM:
Kodak Tri-X
at ISO 200

⇥ CLOTHING SELECTION

The model was clothed in a black thong and a sheer black shirt that was unbuttoned and allowed to fall open, revealing one breast. The sheer fabric and cut of the thong are flattering and sexy, but all serve a compositional purpose—they create contrast that draws your eye immediately to the model, and helps separate her from the sky (which is otherwise very close in tonality to her skin).

Model: Dale

HINTS AND TIPS

For the most part, when I work with an experienced model such as this one, I let her take the lead in terms of posing. I look at my role in this type of shoot as more of an observer. I fine-tune and give feedback, but mostly let the model express herself with the poses that appeal to her.

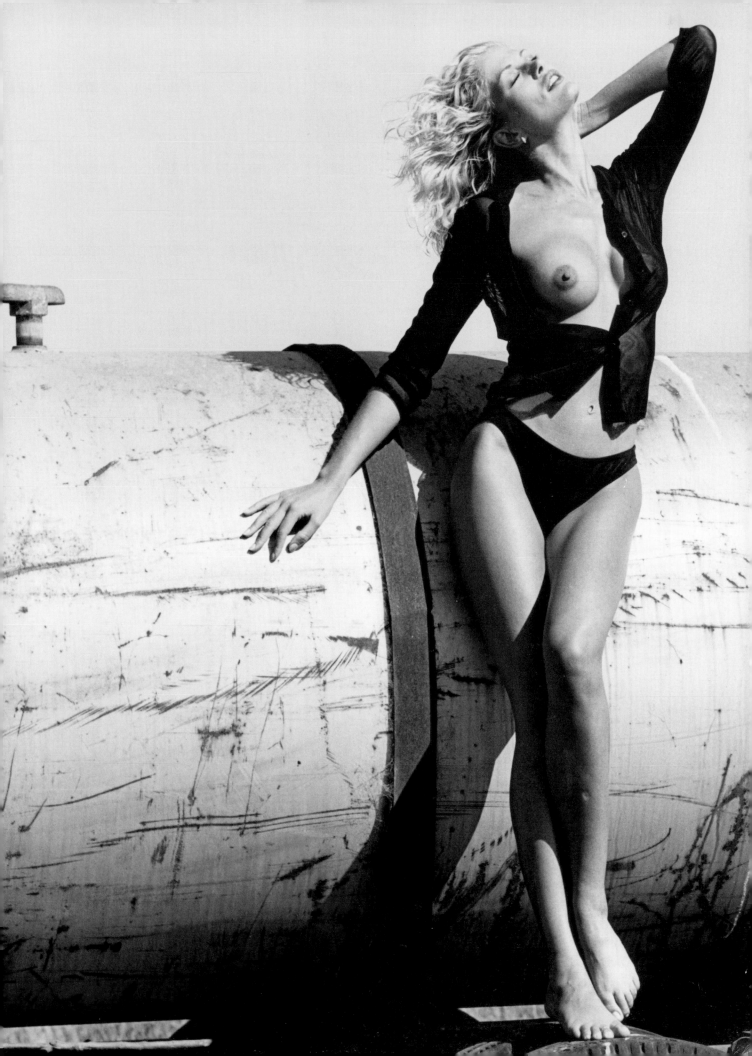

POSING VARIATIONS

SETTING

If you refer to the previous image, you'll note that this photo was taken in the same spot and with the same model. It was also taken on the same day. The model simply turned around and removed her top for a series of images that emphasize her attractive legs, back and buttocks.

CAMERA:
Nikon FM

LENS:
80–200mm

FILM:
Kodak Tri-X
at ISO 200

POSING

As you can see in this contact sheet, which depicts a series of images from the same shoot, I like to experiment with many small variations of poses. As I've already mentioned, I like to let experienced models take the lead with posing and express themselves in poses that they like and feel comfortable with. After we had shot the image on the previous page, the model suggested that we take some shots of her from the back. Without changing locations, we simply modified her pose, moving her to face away from the camera. Once she was in position, the model tried several variations on the basic pose.

ANALYSIS

I think my favorite image of the series is frame 21A. I like the way the wind is catching her hair, and the symmetry in the placement of her arms. I also like the way her legs are slightly crossed, creating a slim, lean look that really emphasizes her buttocks and back.

Model: Dale

HINTS AND TIPS

Learning to self-edit your images is an important skill to develop. For each set of images, you must carefully evaluate the subject (here, the model), the exposure (pay special attention to the model's skin), and the composition of the image. Once you've narrowed the choices by cutting out images with obvious problems, take a short break and come back to the remaining images with a fresh eye to make your final selection (or selections).

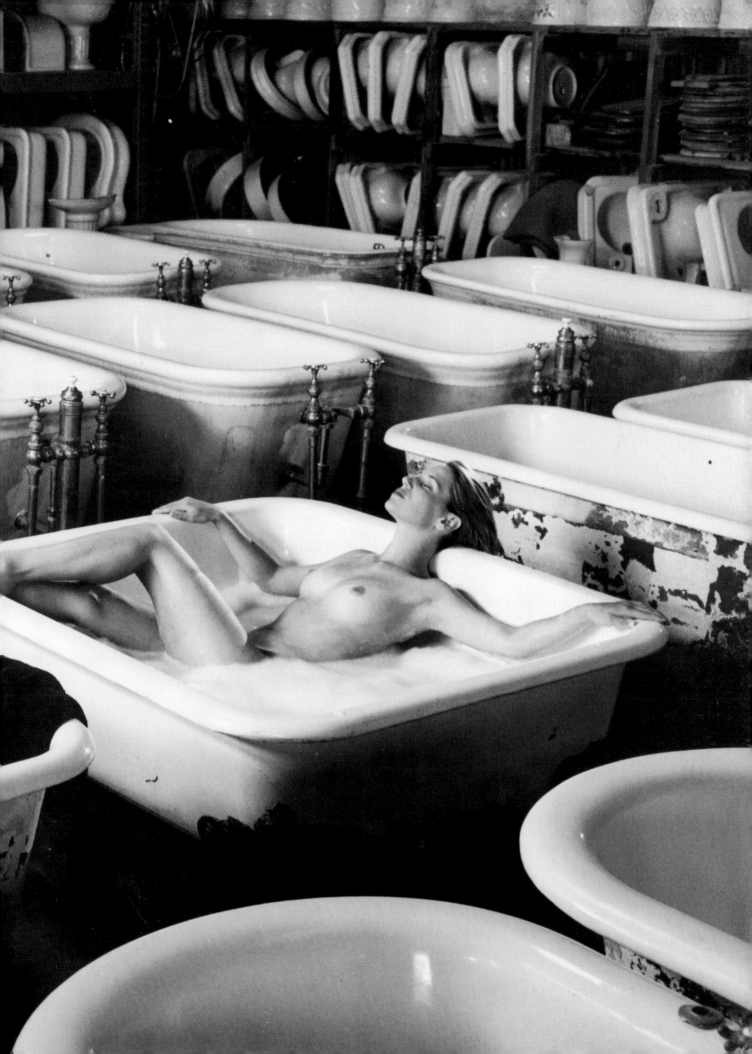

See full image, pages 12–13.

➽ SETTING

This image has it origins in a magazine cover I was hired to shoot for a health magazine. The magazine wanted an image of a woman bathing in an antique tub, which was to be placed in the middle of a large field. Before we could create the image, I needed to find an antique bathtub that could be rented for the shoot. That search led me to this location, an antique bathroom fixture warehouse. As it turned out, the cost to rent the bathtub was prohibitively high and I never ended up shooting the magazine cover—but I did find this great location.

➽ PROPS

Before the shoot, I visited the warehouse to take some test shots and try to plan out the image. I had originally planned to photograph the model in one of the other bathtubs, but it turned out that the tub was too deep—I'd hardly have been able to see any of the model in the photograph. Instead, we decided to use this larger, more shallow tub which permitted a perfect view of the bathing model. The manager of the warehouse was kind enough to empty his hot water tank in order to provide water to fill the tub, and my image stylist brought along bubble bath to create the foam. We also hung a dark towel over the edge of the tub near the model's feet in order to create a little sense of narrative and another area of interest.

➽ POSING

When I pictured the image in my mind, I wanted the model to look relaxed and sensual as she reclined in the tub. I wanted to see her breasts, but not have full frontal nudity. As such, I posed the model with her head tipped back and her hair draped down over the back of the tub. Her arms are casually extended to the edges of the tub, allowing us to see her breasts. The leg closest to the camera is bent, giving us a great view of the model's attractive legs, but concealing all else.

➽ LIGHTING

There was some natural light in the room from a skylight overhead. This was supplemented by two lights. I chose to use tungsten lighting, since there was a huge quantity of reflective surfaces in the room. Continuous lighting allowed me to see and predict exactly what I would get. This meant I could immediately correct for any unwanted reflections. The first light was placed out of the frame to the right; this is the light that catches on the model's hair. The second light was placed to the left of the frame; this was a large light source that provided the main-light for the image.

Model: Kirsten

CAMERA:
Pentax 6x7

LENS:
75mm, f/4

FILM:
Kodak Tri-X
at ISO 400

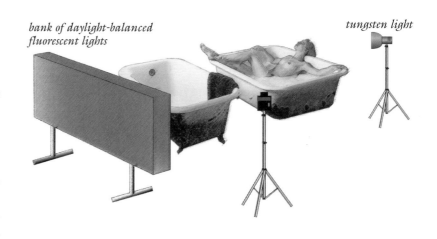

bank of daylight-balanced fluorescent lights

tungsten light

CONCEPTS

See full image, pages 16–17.

❧ CONCEPT

This image was conceived by the model, who brought this ornate mirror along to the shoot. As I tell my students, photographers would do well to listen to their models more often. I have very often found that my models, especially those with significant experience working with a wide array of photographers, bring wonderful, fresh ideas to the shoot.

❧ LOCATION

For this shot, we went to the beach. Posing the model in the sand with grasses all around her fills the frame with fine texture. The grass in the foreground also recedes into a sandy area and then off into more grass, creating a sense of depth in the frame.

❧ LIGHTING

While this might look like a simple shot, it was actually a bit tricky to set up. First of all, since a large portion of the frame was to be occupied by a highly reflective surface, it was important to carefully position the mirror so that there would be no glare from the sun and so that no distracting elements would be reflected by it. To reduce the potential for glare, the model and mirror were positioned so that the light ran parallel to them. Looking at the reflection of the model's thigh, you can see the direction of the light. Remember that, when using a mirror in the frame, this very effective reflector also becomes a source of light that must be taken into consideration. Here, the mirror bounced light onto the front of the model, illuminating her face and making her breasts visible through the sheer fabric of her bodysuit.

❧ COMPOSITION

Shooting this image basically required me to compose two pictures in one frame. The first was the image in the mirror. Since this image was my point of focus and formed the primary area of interest in the photograph, I had to compose it carefully. It was also important, however, to pay attention to the second image—the actual model, the mirror itself and the environment around them.

CAMERA:
Nikon 8008

LENS:
35–70mm

FILM:
Kodak TMZ
at ISO 1600

❧ CLOTHING

The sheer dark bodysuit helps separate the model from the sand and grasses around her. Without it, her skin tones would be very close in tonality to the environment and, therefore, poorly defined from it. The sheer fabric does, however, allow us to see her breasts reflected in the mirror in front of her, and this was also a desired feature of the image as we envisioned it. You'll also note that he model chose to wear black underwear. This is because she wanted to create an image that would be reserved enough to be used in her own portfolio.

Model: Dale

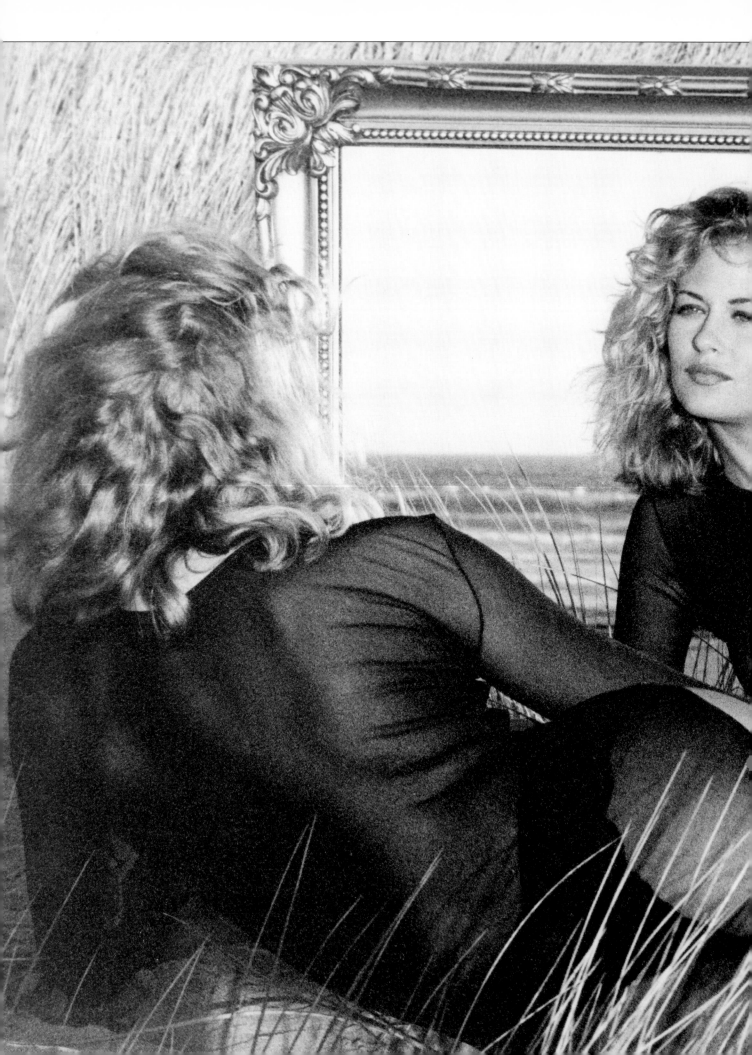

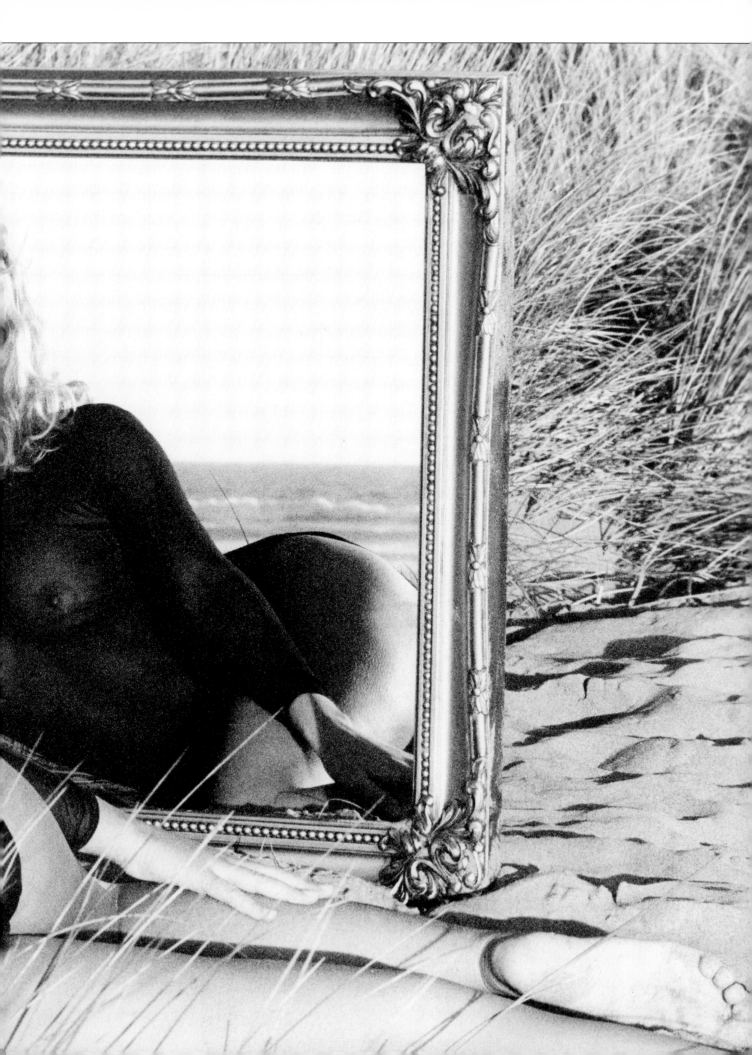

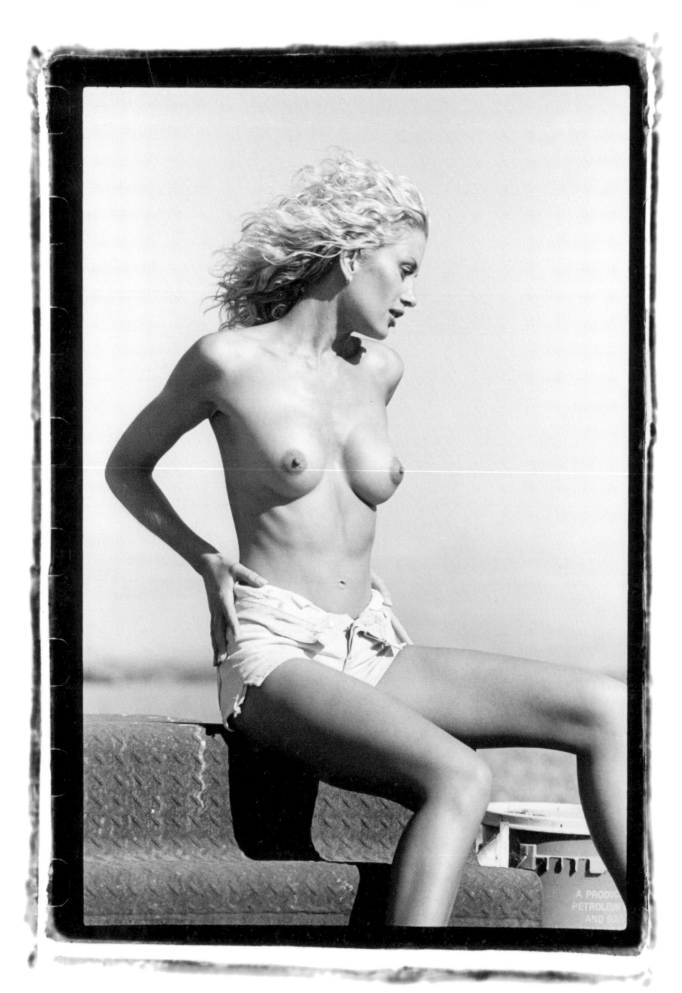

BORDERS

CAMERA:
Nikon FM

LENS:
80–200mm

FILM:
Kodak Tri-X
at ISO 200

❧ LOCATION AND LIGHTING

This image was created outdoors using natural light. The model was posed on an old set of metal steps. These sit near the former site of an old barn, along with several pieces of old farm equipment that I love to use as props in my model photography.

❧ CLOTHING

For this image the model was wearing shorts which were pulled up quite high to create the longest possible line on her legs. If they'd been left buttoned up, the waistband would have come up quite high on the model's torso. The result would have been the appearance of an unattractively short upper body. To avoid this, I had the model undo the waistband partway and roll the top of her shorts down. This added a seductive flair to the image and an improved appearance of the model's body. The length of the model's torso and the length of her thigh are approximately equal, making the image look balanced.

❧ POSING

This seated pose, with the model's legs running diagonally out of the frame and her face in profile, is strong and sexy. The position of her legs makes her thighs and calves look lean and shapely, while the position of her arms and slightly arched back makes her breasts full and her waist trim and flat. The gust of wind that picks up her hair adds a sense of movement to the image.

❧ BORDER

The rough border on the edge of this print is a result of actually printing the edge of the negative. This means you can't crop the image at all, but does create an interesting look. The border has a rugged feel that suits the rugged setting of this image. It also helps to strengthen the composition by strongly defining the edges of the frame.

❧ DISTRACTIONS

If there was one thing I could change about this image, I'd move out of frame the bucket that now appears between the step and the model's left leg. On the other hand, if we imagine this woman just walking up to the steps unobserved (not a part of a photo shoot), it's likely she wouldn't have moved the bucket either. Sometimes little distractions like these do creep in, and we have to live with them. We must also remember to look at them in the context of the overall quality of the image.

Model: Dale

MODEL

I met and photographed this model several years before this particular image was taken. She responded to a model search I was running when she was only about sixteen years old. Although she was very pretty when I first photographed her, I didn't spot the beauty that she would develop into in just a few years. It was by sheer coincidence that I ended up photographing her again. I ran into a friend at the supermarket who said, "Have I got a model for you!" He referred me to her and, since she already knew me and liked my previous work, she decided to do another session. This image and the one on the following page show the results.

EXPRESSION

The single most important factor in the success of this image (and the first place you probably looked when you saw it) is the model's beautiful face and her strong eye contact with the camera. Those eyes speak far beyond the reaches of the frame. When working with a model on poses, capturing the expression you want can be one of the hardest things to

CAMERA:
Hasselblad 500cm

LENS:
150mm

FILM:
Kodak TMX
at ISO 100

achieve. I find that I'm better off giving the simplest instructions I can manage, and as few of them as possible. It's stressful enough being in front of the camera; many models get confused and stressed when confronted with a lot of complex instructions on top of that baseline stress. You need to evaluate this on a case by case basis, of course. For instance, I might ask a model to imagine she's watching her boyfriend walk around in his underwear. One model, hearing this, might give me exactly the sensual expression I want, while another may simply laugh.

LIGHTING

This image was created on a very bright day—as you can clearly tell from looking at the very hot areas on the edge of the door and through the glass around the subject. To achieve the soft, even light that I wanted to make the model's skin look smooth and flawless, I positioned her inside an old farm truck. The shaded, indirect light was very soft and flattering. You'll notice that the model's left hand protrudes slightly out of the cab and is thus somewhat hotter (brighter) than the rest of her body.

POSE

The model's pose is casual and strong—well suited to the rugged setting. Because the model is not large-chested, I had her lean slightly forward, creating definition that makes

her exposed breast look more full and round. Given the current trend toward larger breasts, small-breasted models will generally appreciate poses like this that create the illusion of a fuller chest. The pose also, however, highlights one of this model's strongest features— her long, shapely legs.

HINTS AND TIPS

If I could make a slight refinement to this image, it would be to have the model remove her toenail polish and ankle bracelet. I prefer natural-looking nails on my models, and the toenail polish here is slightly distracting (especially since her fingernails are bare). I also prefer not to photograph models with jewelry, since it can cause spots of glare. Here, this isn't much a problem, but I'd still prefer the image without it.

Model: Kym

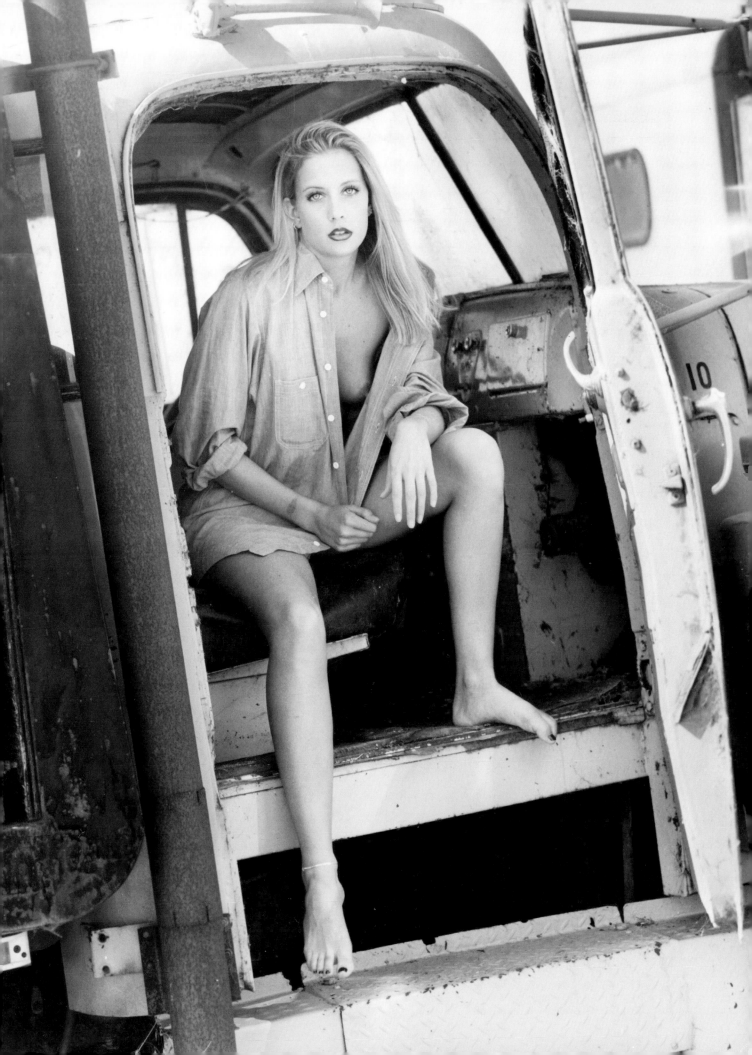

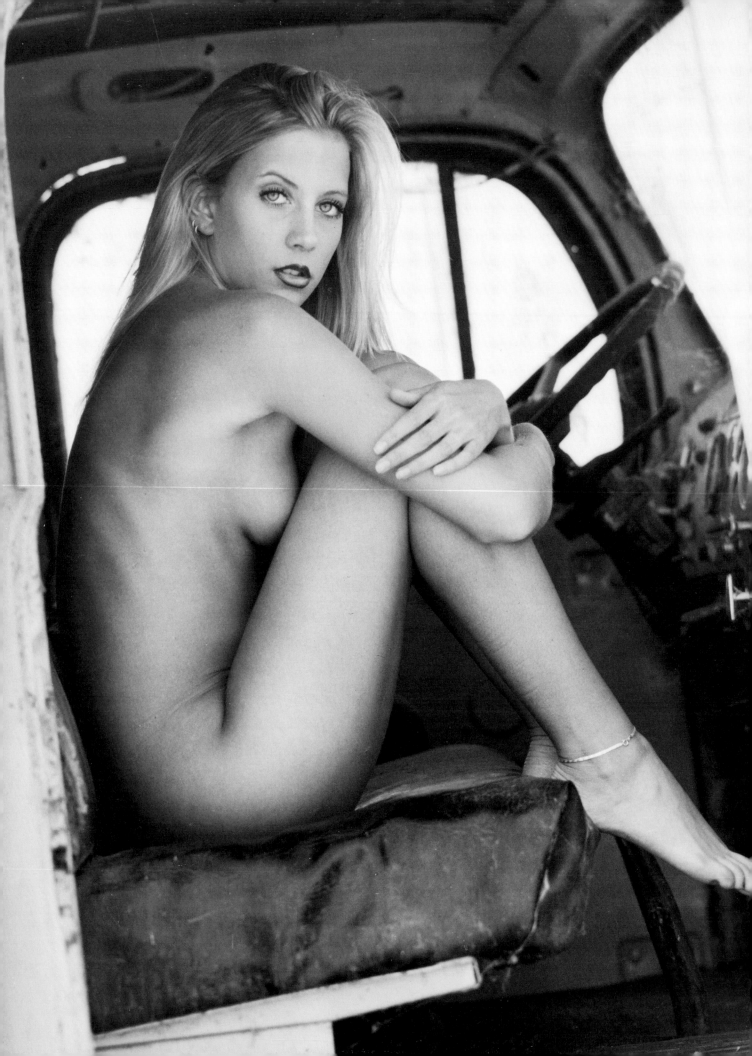

JEWELRY

➻ LOCATION

As in the previous image, this photograph was shot in the cab of an old farm truck on the grounds of an old farm where I love to shoot.

➻ LIGHTING

Because the sun was very intense, I posed the model inside the cab where the indirect light was much more flattering.

CAMERA:
Hasselblad 500cm

LENS:
150mm

FILM:
Kodak TMX
at ISO 100

➻ POSING

Shot in the same location as the previous image, the model simply removed her denim shirt and turned her body in profile to the camera, tucking her heels up onto the edge of the truck's front seat. This created a fully nude image that isn't terribly revealing. In addition to showing off the model's legs, this pose also helps to make her breasts look more full.

➻ JEWELRY

As I mentioned in the previous discussion, in retrospect, I would have asked the model to remove her anklet, which does catch a bit of light in this image. You'll also notice she has several earrings. Multiple ear piercings (often running continuously from the lobe to the top of the ear) are becoming increasingly common. I generally don't mind earrings as long as they are small and simple (like these hoops). In fact, with a model who has numerous piercings, removing the earrings can create new problems in the form of a row of tiny holes left behind (which can be just as noticeable as the jewelry was).

Model: Kym

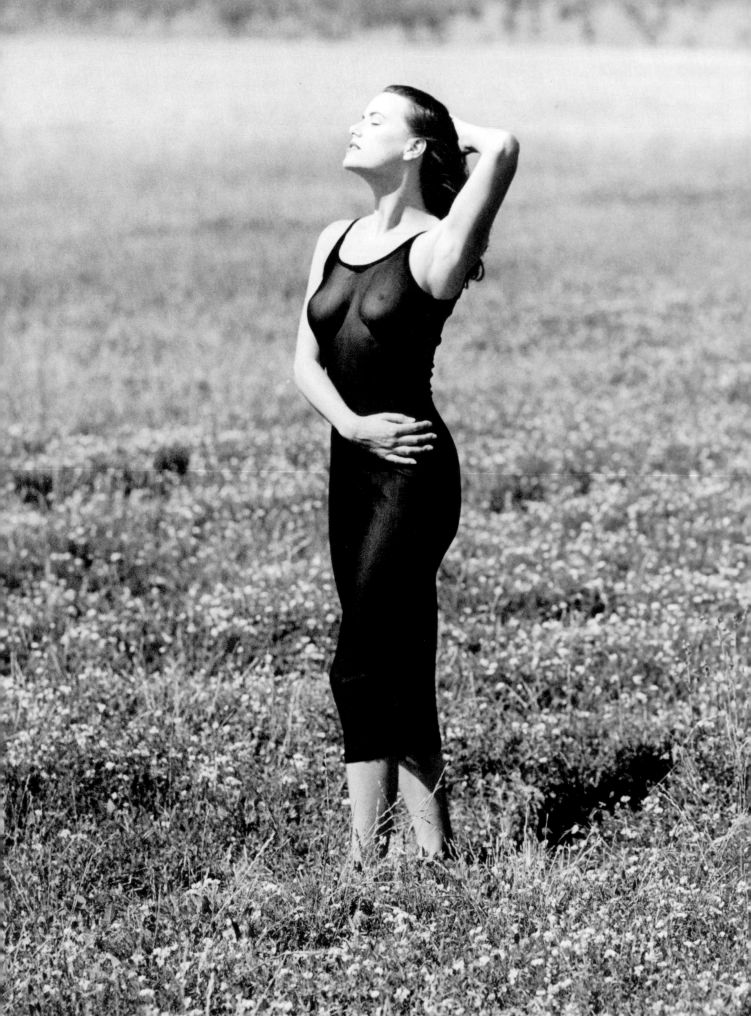

SUNLIGHT

⊷ LOCATION AND LIGHTING

This model was posed in the middle of a very large field. The sunlight was very strong, so I had the model turn her face up toward the sun and close her eyes. If her face had not been upturned in this way, her eye sockets would have been left in deep shadow, creating the look of raccoon eyes.

⊷ POSING

Once the model was in position, I watched her as she moved and photographed her when I saw an image coming together. Basically, once I had established the fundamental pose with her face turned toward the sky, I allowed the model to express her own character and preferences in the details of the pose. When she moved her arms into this strong position, I saw the image coming together and took the shot. Notice how her arms frame her face and upper body. The bend of her left leg adds a soft curve to her lower body and continues the line that originates with her arms. During the shoot, I also photographed several images of the same model in a seated position in the field.

CAMERA:
Hasselblad 500cm

LENS:
150mm

FILM:
Kodak TMX
at ISO 100

⊷ CLOTHING

You'll notice that quite a few of the models in this book are wearing clothes made of very sheer material. This is a favorite fabric of mine because it allows me to create an image that is revealing (showing the breasts, buttocks, etc.) but not as overt as a truly nude image. The shots are sensual but understated. A second reason for using garments like this is that my models really like them. As anyone can well imagine, taking your clothes off and posing for photographs can be a pretty intimidating experience. Sheer clothes allow models to create sexy images that are almost as revealing as nudes, but also give them a greater sense of comfort from being "dressed." As you shoot model photography (especially nudes) you learn fast that if models are

uncomfortable, you're not going to get usable images—so anything you can do to put your models at ease is to your mutual advantage.

⊷ COMPOSITION

Normally, when a model is facing strongly in one direction I allow extra space in the direction she is facing—creating a space for her to "move into." In this photograph, however, I chose to center the model. The contrast of her dark dress with the field around her and the strong position of her arms seemed to make a strong enough impact to allow for this prominent position.

Model: Janine

COMPOSITION

CONCEPT

The idea for this image came from a Calvin Klein advertisement, in which the model was depicted wearing panties and a tank top. In some versions of the shot, the tank top covered her breasts, and in some it was pulled up over them. I strongly recommend that people interested in doing model photography (or in improving their posing techniques) make it a habit to study fashion, music and other popular magazines. Every month these publications offer almost unlimited ideas for depicting the human body in creative and flattering ways. All it takes is a little analysis to understand the set-up and copy or adapt the images in your own studio (or on location).

CAMERA:
Hasselblad 503cx

LENS:
150mm

FILM:
Agfapan 100

SETTING

This image was shot in my studio. A board was placed at an angle from the floor and supported at the high end by a ladder. The model was then posed laying across this board. The backdrop was black seamless paper.

LIGHTING

This image was shot using one light—a large softbox aimed squarely at the front of the model's body. The single light source provides soft lighting across the model's body, catching on the edge of the board and her hair to provide definition and detail in these areas.

POSING

The model is posed leaning diagonally across the frame, supported by a board. Her back is arched, making her stomach perfectly smooth and flat. Her arms are also raised over her head, making her breasts look their best. The model's bent arms also frame her strong profile and accentuate her beautiful face.

COMPOSITION

The diagonal composition of this image creates a strong, dynamic line in the image. The viewer's eye travels the length of the model's body, moving from her white underwear (the brightest spot in the image) and her face (again, strongly framed by her upraised arms). By almost forcing the viewer's eye to continually move around in the image, the composition creates a photograph that holds your attention and is visually compelling.

Model: Kirsten

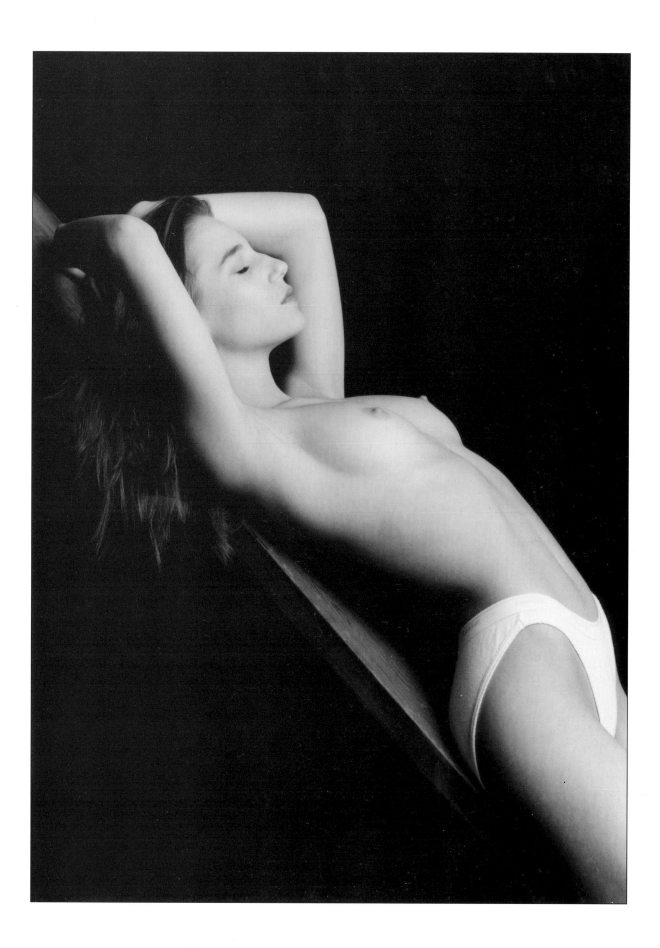

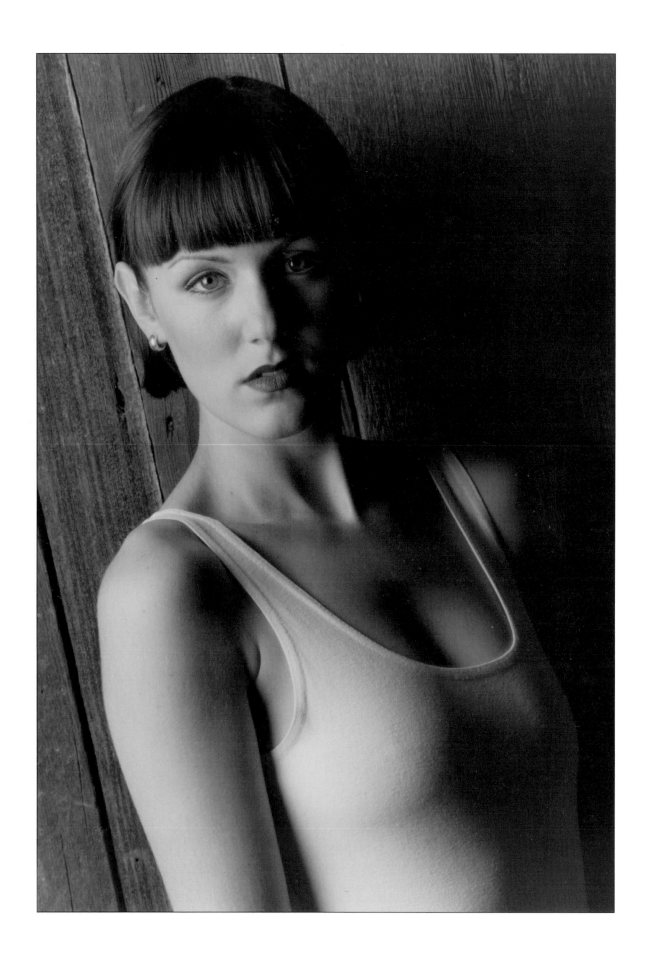

COMFORT

MODEL

This model is a beautiful woman whom I'd had the opportunity to photograph several times before. Her strong and elegant face combined with her dramatically dark hair and toned body had resulted in numerous strong images from the sessions. When I photographed her this time, she was the mother of three and felt strongly that, although she was still in great shape, her body didn't look like it did before having children and she didn't want to do any topless images. Thus, I shot this strong portrait of her in a tank top.

LIGHTING AND POSING

We were both in a hurry and had very little time to fuss with complicated shots. It was also a spur of the moment kind of session, and I wasn't sure it was going to produce any great results. Consequently, I kept the setup very simple, using one light (a softbox from camera left) and posing the model leaning up against a barn board wall that is permanently installed in my studio. To my surprise, this lovely image was the result. The dramatic lighting ratio and the model's strong expression combined to create an image that is truly striking.

COMFORT

When you work with models (especially when doing nude or semi-nude work) it is extremely important to remember how fragile egos can be. Think before you speak. From time to time, you are going to encounter a model who has some kind of figure problem that needs to be concealed. This doesn't, however, give you free reign to talk about it—she'll probably be destroyed if you do. If you know a particular pose isn't producing images that either you or she will find flattering, do something else. For example, if a model's breasts don't look great, consider photographing her from behind. Have her lie on her back and photograph her from above. Pose her with her hands over her breasts or drape her creatively in a sheet. The possibilities are nearly endless. Adopting any of these ideas means you can say, "Why don't we try this?" instead of "That looks awful!" This will spare her feelings and help build a comfortable and productive atmosphere for getting shots that *do* look great.

Model: Colleen

CAMERA:
Pentax 6x7

LENS:
165mm, f/2.8

FILM:
Ilford FP4 Plus

barn board wall

camera at an angle

softbox

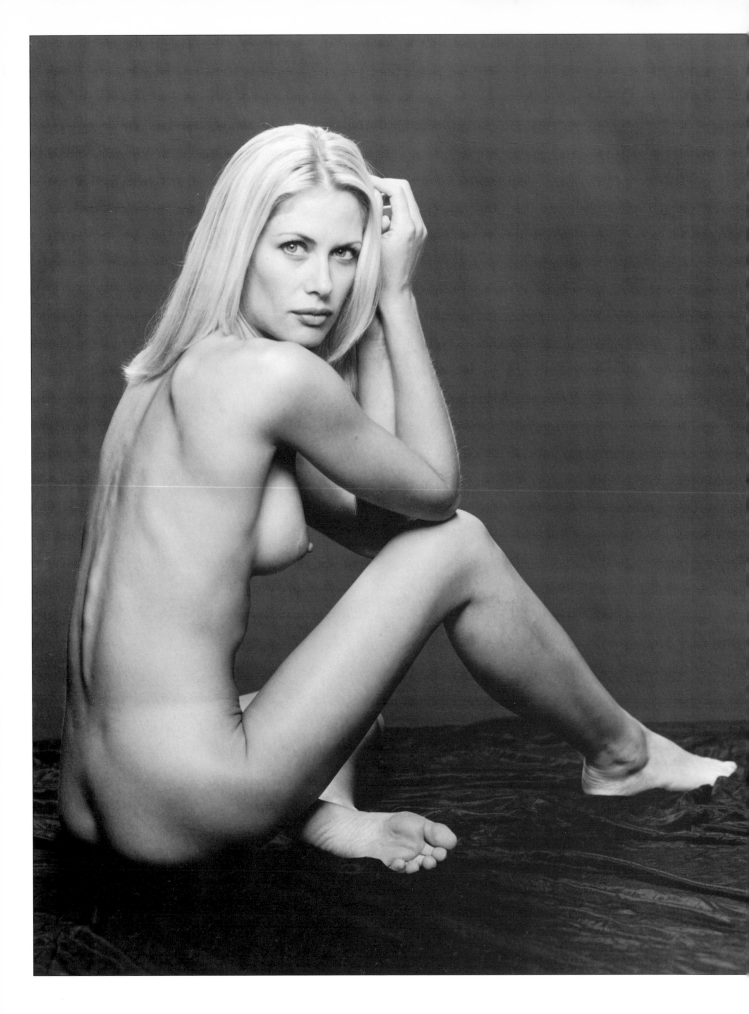

FULL NUDE

◆ SETTING

This image was shot in my studio. The model was posed in a seated position on a posing platform covered with a dark nylon fabric. The backdrop was black seamless paper.

CAMERA:
Pentax 6x7

LENS:
165mm, f/2.8

FILM:
Agfapan 100

◆ POSE

This seated pose is very flattering and shows off almost all of the model's body without full frontal nudity. You can see the trim, toned shape of her legs, her shapely back and buttocks, the curve of her waist and (in profile) her chest. What really makes the photo, though, is the model's face and her engaging expression. Notice how the lines of the pose lead your eyes to hers. Her face is framed between her very gently clasped hands and her shoulder. Her smooth blonde hair, close in tonality to her skin tone, falls naturally around her face, also helping to frame it. Even the line of her toes and extended calf lead your eye back to her gripping expression.

◆ LIGHTING

Two lights were used to create this image. The first was a hair light directly over the model.

This was the light that created the highlights in the model's hair and caught on the tops of her fingers. It helped to add sparkle to the hair and created a good sense of separation from the backdrop. The second light was a large softbox, positioned to the left of the camera and slightly above the level of the model. When creating the set-up, I started with the hair light, because this is permanently installed on the ceiling of the studio over the posing area, and therefore the least mobile part of the setup. I worked with the model under this light until I was happy with the way it illuminated her. Then, I moved the mainlight (the softbox) in from the side and positioned it the way I wanted it.

◆ BACKDROP

While the backdrop was black seamless paper, the model was posed relatively close to it, so light spilled over and rendered the paper a dark gray instead of pure black. However, if you examine the most darkly shadowed areas of her body (the underside of her thigh, her stomach and far arm), you'll notice that they are, in fact, better defined against the gray background than they would have been against pure black (where there would have been little visible separation).

Model: Dale

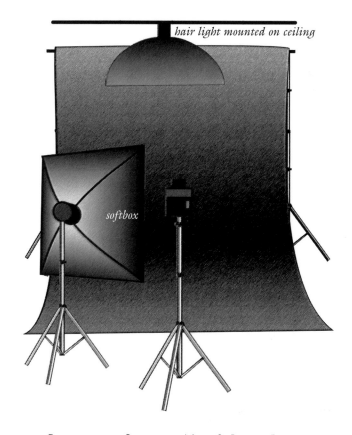

hair light mounted on ceiling

softbox

SOFT FOCUS

SETTING

This photograph was taken with the model posed in her Volkswagen convertible (a type of car her boyfriend makes a hobby of restoring). We drove the car into the studio for the shot, which I photographed from a high camera angle, looking down onto the model in the back seat of the car.

CLOTHING

We tried several versions of this shot, beginning with a full nude. When we found that the fully nude shot just wasn't working, we decided to try creating the image as a partial nude, adding an unbuttoned denim shirt and white panties. This improved the image immensely, contributing more texture and adding areas of interest to the image.

POSING

Despite her limited area of motion, the model's pose is well refined and tuned to the space. Notice how her right arm is lifted. While her elbow cuts out of frame, her forearm leads back in. Her hand is relaxed so that her fingers drape toward her face and lead the viewer to her eyes (as does

CAMERA:
Pentax 6x7

LENS:
165mm, f/2.8

FILM:
Agfapan 100

the diagonal line of the car's interior on which she is leaning). Likewise, her left arm, extended the length of her body, creates a boundary on the right-hand side of the image, keeping your eye on her body. Finally, her left leg is drawn up parallel with the bottom edge of the frame, creating another limiting element that sends your eye back into the frame. These three elements (her two arms and left leg) all function compositionally to frame and emphasize the subject.

LIGHTING

One light was used to create this portrait. This mainlight was a softbox placed above the model and to the left of the frame. Notice that, although I was shooting down at a steep angle, the light pattern on the model's face looks very much like a normal portrait lighting pattern. This is caused by positioning the light in a normal portrait position—but refined in relation to the model's own position.

FILTRATION

A Tiffen SFX3 soft focus filter (which provides light softening) was added to the camera for this image. I have had good luck with this filter; it adds a little softness to the model's skin without objectionably reducing the sharpness on her eyes. You need to be especially careful of excessive softening when shooting black & white images, since the result can be

an image that simply looks muddy and has lost a considerable amount of contrast. In fact, to help improve the contrast of my black & white images (either with or without soft filtering), I often use a yellow filter. This provides overall improved contrast, but is more subtle than the effect achieved by using the red filter that is commonly recommended for black & white photography.

Model: Janine

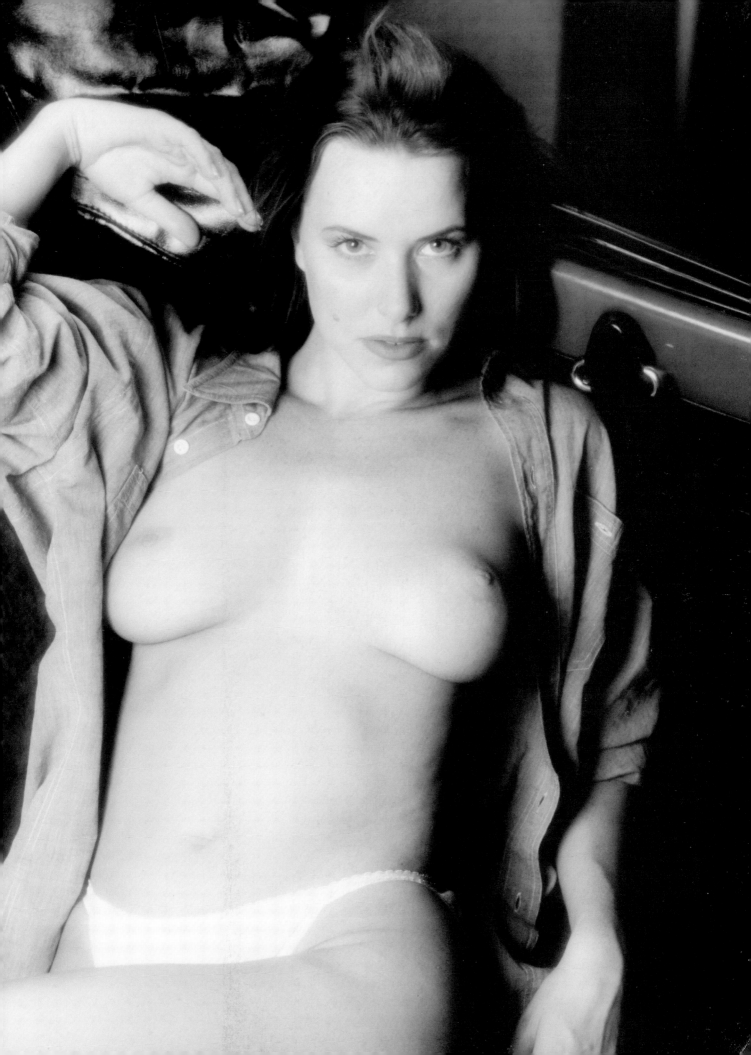

BODY PAINTING

CONCEPT

Take a close look at this image. Can you figure out the secret? This is an example of the great results you can get with body painting! I got interested in doing some body painting images after looking at a recent *Sports Illustrated* swimsuit edition that featured a number of painted-on bathing suits. It struck me that this was a great creative idea that wouldn't be too hard for me to try in my own studio.

MODEL

This model, an actress who has appeared in a number of network television programs, came to the San Francisco area from Los Angeles to do the shoot. She was open to the idea of nude body painting, but didn't want to do images where anything (breasts, etc.) actually showed.

CAMERA:
Pentax 6x7

LENS:
165mm, f/2.8

FILM:
Agfapan 100

SETUP

My stylist came up with this idea and purchased the boldly patterned sheet and pillow case at a secondhand store. I provided the black sheet and pillow cases that were placed under the patterned bedding. Once the model was in posi-

tion, my stylist used body paints (the same type used for face painting and available at most craft shops) to create the illusion of a sheet draped over the model's body. It took about half an hour to do the painting so, if you try this, take care to position the model in a pose that she can hold for quite a long time.

PHOTOGRAPHY

To get the right angle, I shot the image from a loft above the studio where my office is located. This allowed me to look down on the model from about a 45° angle to capture the full effect of the body painting.

LIGHTING

Two softboxes were placed to either side of the model. The lighting setup was simple and designed to produce soft, even lighting across the entire platform. As you can see, the light skimming across the sheets provides great texture.

Model: Jodi
Body painting: Kelly Cazzaniga

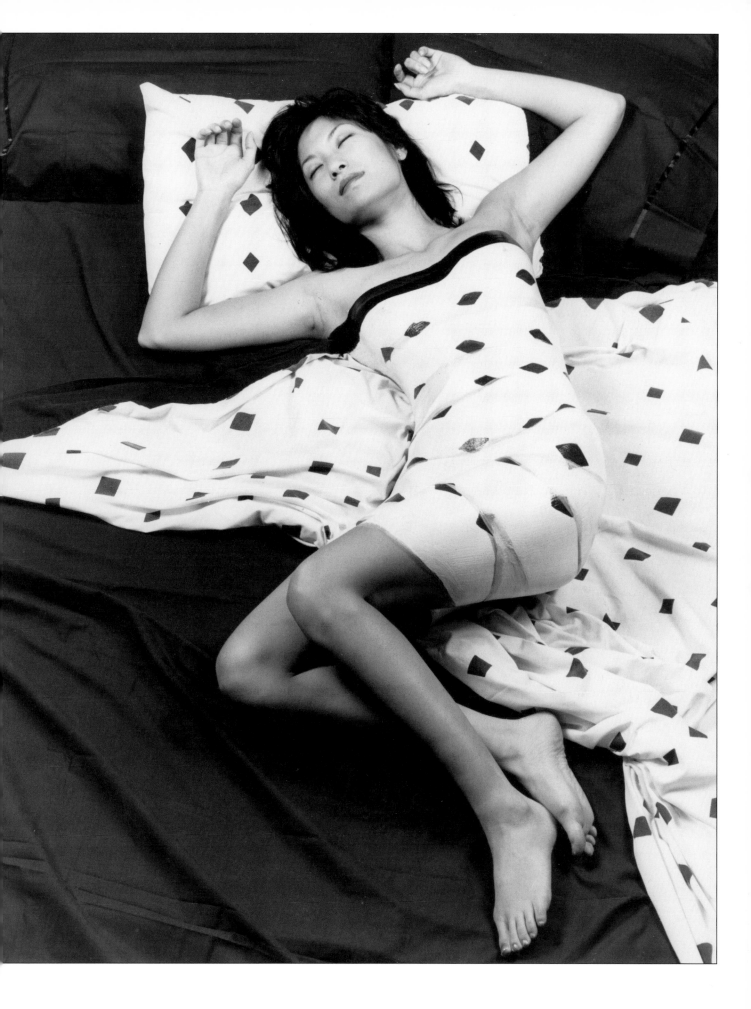

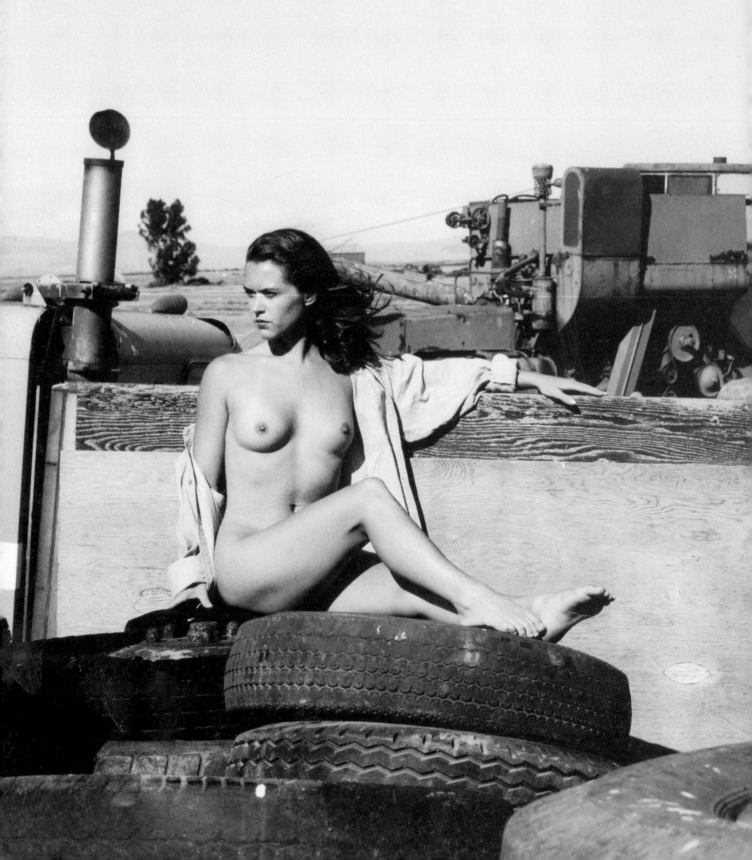

See full image, pages 36–37.

❖ SETTING AND COMPOSITION

This image was shot on the site of an abandoned barn, where the model was posed on the back of a flatbed truck. The tires on which the model was posed make up the foreground of the image. The setting of this image is very large and extends to include the fields, trees and distant mountains that make up the background. The background elements, that create the setting for the scene add texture throughout the frame, and are very prominent

HINTS AND TIPS

I had tried this pose with a couple of other models, but didn't have the same success. I wanted a model with a great, natural-looking body who could convey this strong attitude. I actually met this model for the first time on the day we did this shoot. Her mother had seen my images and mentioned to me that I ought to photograph her daughter. The mother showed me some pictures and I decided that she would indeed make a good model for me. I talked with the daughter on the phone and set up the shoot.

in the image because the model takes up a relatively small part of the frame. What I was trying to achieve was what the human eye sees—a perspective that makes it look as though you had just come upon the scene. Your eye wouldn't immediately go to her, but would see all the other elements around her in the rustic setting.

❖ POSING AND LIGHTING

The way the model is posed had a lot to do with the light. The goal was to get the model's body evenly lit, and to have her looking into the light to provide the right amount of detail on her face. This image was taken late in the year (in September). Since the sun sets father to the north at that time of year, the model was posed looking northwest. Notice the even shadow underneath her chin, which is symmetrical and centered beneath her chin. This shows that the light on her face was also even. If it had been coming from one side or the other, the shadow under her chin would be uneven or off center.

Model: Brandi

❖ CLOTHING

I shot this image (as seen here) with a shirt on the model, and also with the model wearing a bra and underwear. If you look at the model's skin tones you'll see why I prefer this one. Notice that the model's skin is very close in tonality to the lighter-colored boards behind her. Adding the shirt ensures that her body is framed and separated from the wood.

CAMERA:
Pentax 6x7

LENS:
105mm, f/2.4

FILM:
Agfapan 100

STUDIO LIGHTING

See full image, pages 40–41.

❖ SETTING AND LIGHTING

This image was created in the studio. The lighting for the shot came from an 8'x8' scrim with four Norman strobe heads aimed through it. I use strobes that are equipped with modeling lights (a continuous light source) to allow me to position the light sources properly for my setup. The scrim and lights were positioned above the model at a 45° angle to her. As you can see, because the light source is so large, there is no harshness to the quality of the light. Throughout the entire frame the illumination is even, creating very soft and flattering shadows on the model's face and body. Because the model was posed on white seamless paper, there was also a considerable amount of light bouncing off the paper and hitting her from all angles—again, contributing to the very soft quality of the light.

CAMERA:
Hasselblad 500cm

LENS:
150mm

FILM:
Kodak TMX 100

❖ LIGHT SOURCE

The 8'x8' light source was one that I built in the studio in order to create light that would be even softer than that from a softbox. To make the light, I set up two light stands and built a large, square frame out of electrical metal tubing. This frame was attached to the light stands. I then attached a king-size white bedsheet to the square frame. This is much less expensive than scrim material and works very well. This is especially true for black & white photography, where light temperature and color don't matter—but even in color images, using a white sheet in place of perfectly neutral scrim material will probably result in only a very slight color shift that can easily be corrected for. The same setup works equally well outdoors to soften direct sunlight. Simply set up the scrim and place your model under it. One suggestion, though: this is pretty hard to construct by yourself, so enlist the help of an assistant.

❖ POSING

The model didn't want to do any nude images, so she brought along this very feminine, sheer outfit for the shoot. We did a variety of poses with her seated and lying down, but I liked this one the best. This type of pose is great for a body shot—showing off her slim legs and the curve of her waist. A pose like this, with the model on her stomach, also makes her breasts look as full as possible.

Model: Caroline

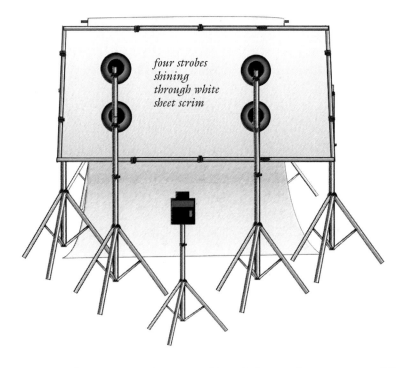

four strobes shining through white sheet scrim

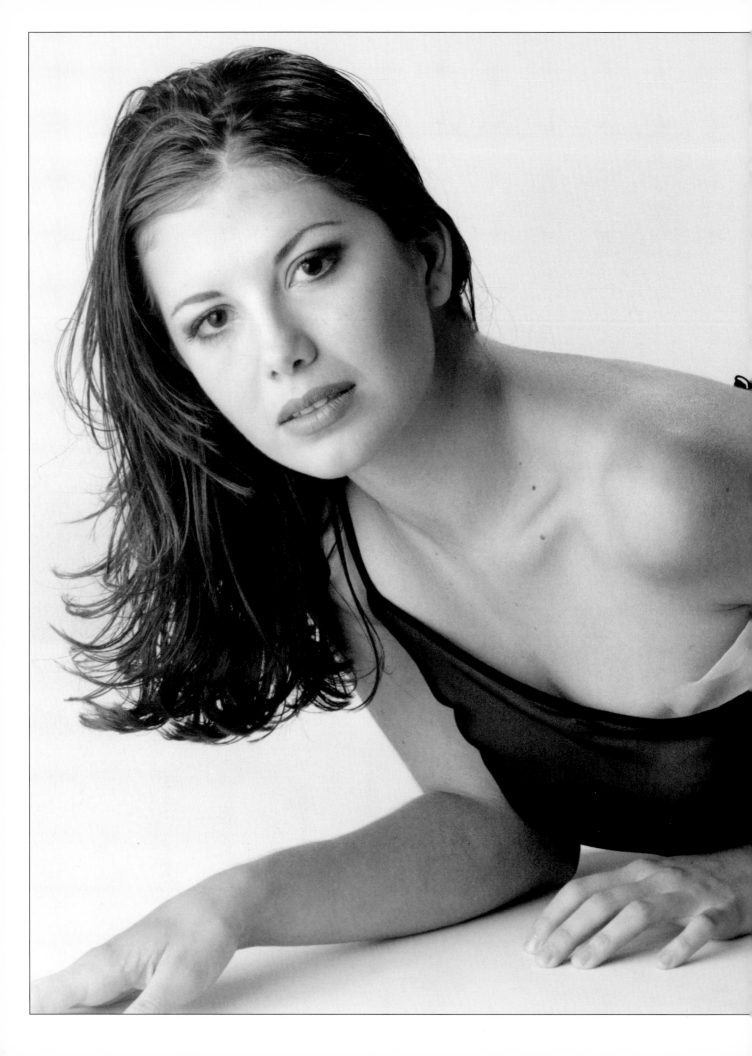

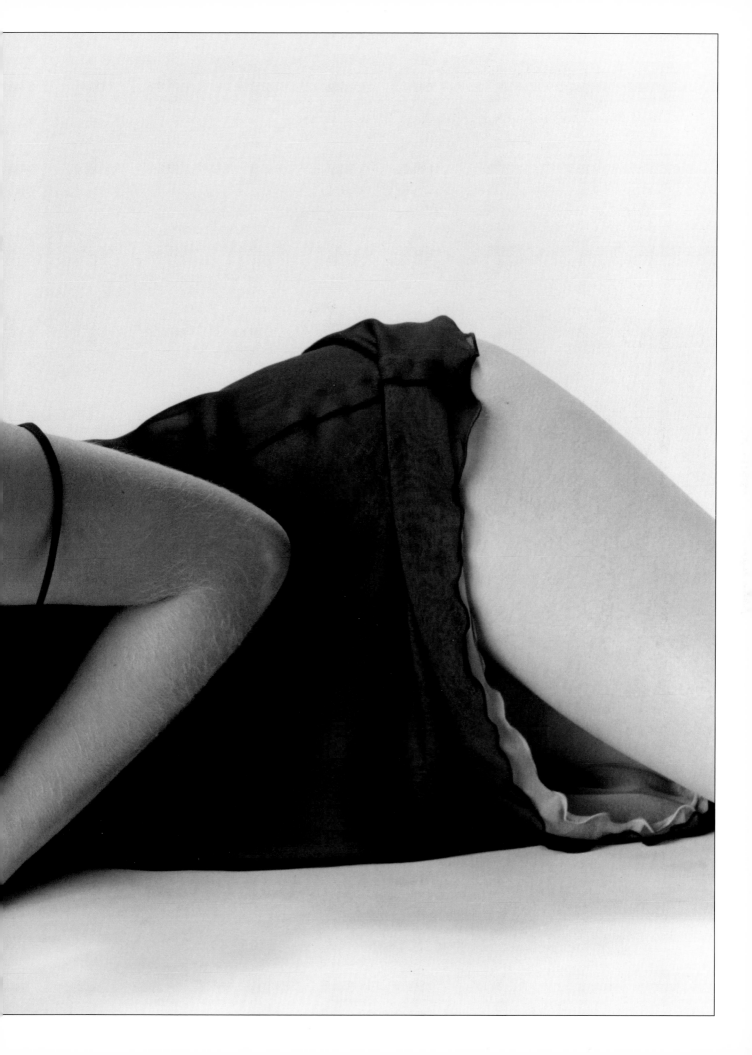

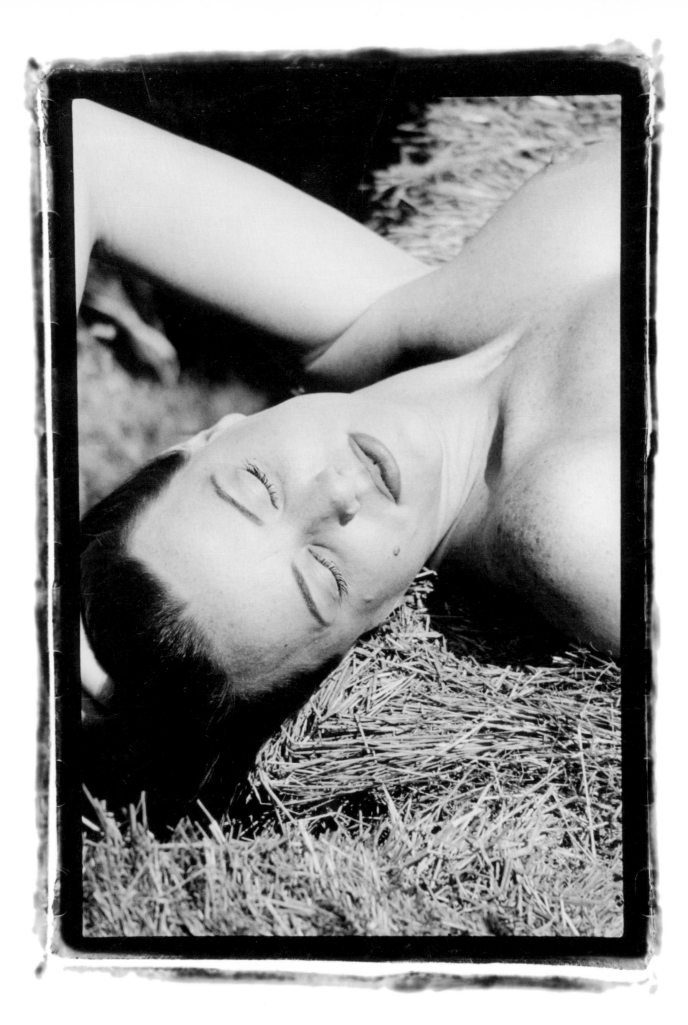

TEXTURE

↠ COMPOSITION

This photograph has a very geometric composition. A strong line runs from the model's face in the lower left, and follows her body up to the exposed breast in the upper right corner of the frame. Her left elbow is lifted and bent, forming another strong diagonal leading from the center of the frame up to the top left corner. The composition and pose also lead the viewer's eye right to the model's beautiful face—which is the focal point and emphasized feature of this shot.

↠ POSE

The model was photographed while lying down on a stack of hay.

↠ TEXTURE

The strong, coarse texture all around the model contrasts with the smoothness of her skin.

↠ NEW IDEAS

I shot this image in a number of ways, as I do most images. I'm always asking myself how I could look at a model or a pose or a scene in a different way. I spend a lot of time examining other photographers' work in magazines, on the Internet, etc.—all to help me become more creative in my own work. I find that too many photographers get stuck in a creative rut and grow too attached to doing things the way they always do them.

Many are unwilling to even try new ideas. My feeling is that you have to take some risks, shoot some images you aren't sure about, just to see if maybe you'll like the results. After all, what's one frame? If it turns out you like the shot, great! If not, it's not a disaster. And either way, you'll have learned something.

CAMERA:
Nikon FM

LENS:
80–200mm

FILM:
Kodak Tri-X
at ISO 200

Model: Janine

COUPLES

The two models in the photograph are an actual couple, and both have modeled for me individually. They called me and said that they'd like to have me take some photographs of the two of them together. I asked if I could get creative and do what I wanted to do—and they said "Sure!" This was one of the images that resulted. It's not the one that they chose for themselves, but it's the one I like the best.

LIGHTING

This was shot inside an abandoned barn. The shoot took place in the early morning, and the models were posed near an open, east-facing door. This is the main source of light in the image and provides the directional quality of the lighting you see on the models. As you can see, there are also a large number of broken-out boards in the barn, providing a lot of ambient light throughout the area. A large open door to the north (quite distant from the models) throws some very soft fill light on the back of the female model's body. The upper part of the end of the barn is also wide open to the sky, resulting in a natural hair light from above the models. You can note the effect especially on the male model's hair, on which a highlight helps to separate his darker hair from the dark barn boards behind him. The same light also creates rim light on the back of his neck. All it took to take advantage of the natural light conditions in this location was some careful attention to posing—making the light work for the image.

POSING

I had seen a pose that was similar to this and started with that in mind as the basis for this image. I made variations that suited the light. Look at the male model's face. It's dark, but you can see detail on it. If the female model's face had also been tilted down, it would have lost detail. Instead I had her turn her face up and into the light. This creates a good exposure on her skin, and also defines her face from his.

FRAMING

I framed this image from the knees up because the female model, who was much shorter than the male, was standing on tiptoes to bring her upper body into the right position in relation to his. I think this framing also helps to focus on the most interesting area of the scene—their bodies, his hand placement, and the couple's faces. Showing the couple full-length would dilute some of this emphasis.

Models: Shawn and Kirsten

CAMERA:
Nikon FM

LENS:
80–200mm

FILM:
Kodak TMZ 100

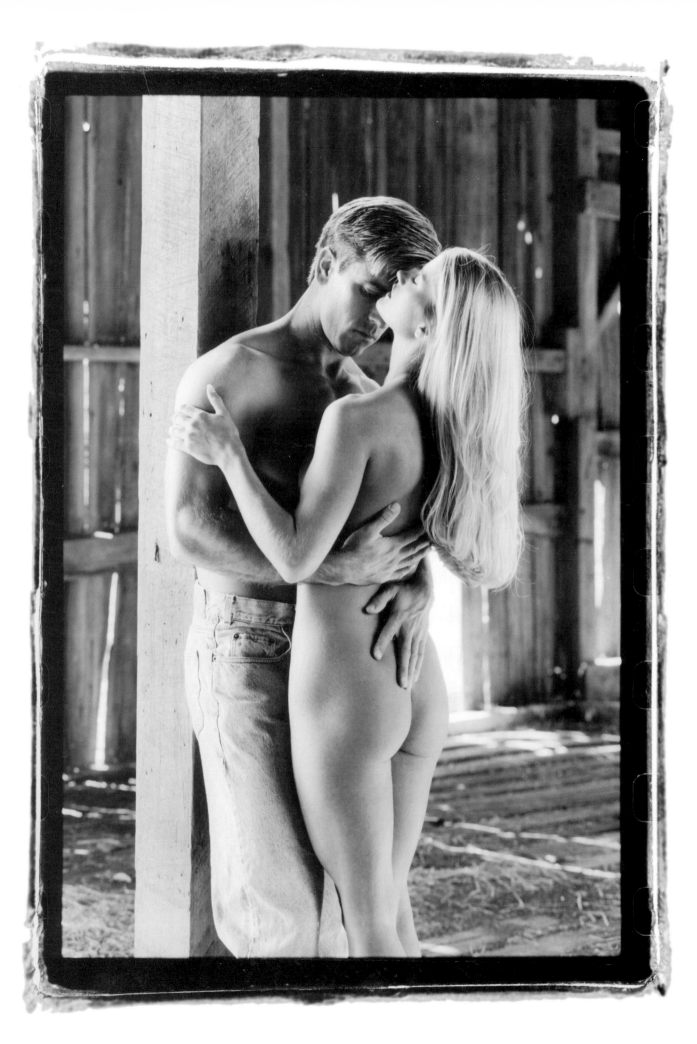

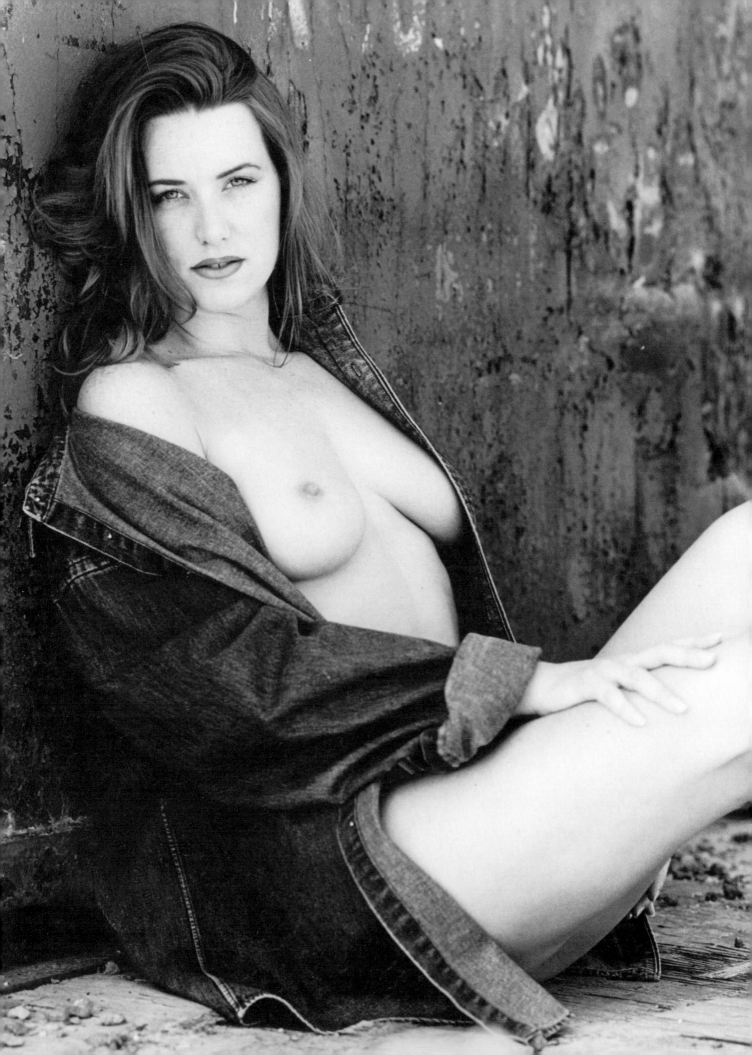

CONTRAST

SETTING

This image was photographed on a flatbed trailer located on the site of the abandoned barn —one of my favorite shooting locations, until it was torn down. Behind the model is a large metal shipping container.

LIGHTING

The sunlight was very intense at the time we were shooting this image. Notice the hot spot right at the very bottom edge of the frame. To keep the model out of this very bright light, I selected a location that was in open shade. In this case, the shade was provided by the metal container that forms the backdrop for the image.

CAMERA:
Pentax 6x7

LENS:
165mm, f/2.8

FILM:
Agfapan 100

CLOTHING

I could have shot this image fully nude, but I thought that adding a denim shirt contributed to the image in a couple of ways. First, it created an element with which to frame the model's chest. Second, I love the rugged look of denim—here it adds another layer of texture to the image. I bring a selection of clothing with me to my shoots on location—underwear, sheer garments, old jeans, shirts, etc. Finally, since the model wasn't

totally comfortable doing fully nude work, she was actually wearing underwear for this shot (also important for he comfort in sitting on a rather dirty surface). The denim shirt conceals her underwear and creates the illusion that she is actually nude.

POSING

This pose shows off both the model's face and body. The image shows the model looking straight into the camera— making strong eye contact with the viewer. This full-face view draws attention to her strong eyes and lips. Again, a denim shirt was added to the shot to help frame and emphasize her breasts. Finally, her legs are lifted and bent slightly, making them look long and lean.

SAFETY AND COMFORT

When shooting outdoors, it's important to provide for the model's comfort. We bring water, rags and towels so we can clean up as needed before having a model pose in a particular spot. I warn models to be very careful walking around and to watch out for broken glass and such on the ground. Many models bring tennis shoes with them, which is great, because they can get in position with the shoes on and the kick them off quite easily.

CONTRAST

There are two levels of contrast in this image and both are used to draw the viewer's eye to the main subject—the model. First, the model is the lightest element in the frame. Our eyes are always drawn to brightness. Here, that means we look at her first. Second, everything else in the frame has a strong, rugged texture. This places an emphasis on the one smooth, soft element in the frame—the model.

Model: Janine

S H A D E

CAMERA:
Pentax 6x7

LENS:
165mm, f/2.8

FILM:
Agfapan 100

▸▸SETTING
This image was created on a little wooden footbridge out behind the abandoned barn. I tried for a long time to use this bridge as a prop, but without a lot of success. The bridge is situated on an east-west orientation (making the lighting tricky) and the background in the distance is very boring. These problems make choosing the correct camera angle and time of day critical for getting a successful image on the site. I selected a relatively low depth of field because I wanted the reeds directly behind the model to go out of focus. If they had been sharp, the background would have been much too distracting. As a result of the shallow depth of field, you'll notice that the model's toes are also not sharp. The important part of this image is the model's face, and that was where I concentrated on getting a clear, sharp focus— that's the part of the image I most want the viewer to look at.

Model: Robyn

▸▸ CLOTHING
The model wanted to do images that were sensual and beautiful, but not nudes. Because she didn't want anything to show, I posed her in a sheer black top and panties that conceal well, but reveal a little more than an opaque fabric. Note, for example, that the fabric allows you to just barely see the top of her breast and more of her cleavage. Letting the strap of her top drop off her shoulder adds a little sensual flavor and breaks up some of the symmetry of the image.

▸▸ LIGHTING
Today, everybody has busy schedules. As a result, it's often hard to schedule shoots when the lighting is best (early morning or late afternoon). Instead, I often end up shooting when the sun is hot and high in the sky. Since I can't change the light, I simply have to find ways to work with the light as it is. For example, to avoid creating dark shadows on the model's face, I simply had her turn her face up toward the sun to create an even lighting pattern. To keep the light from being too bright on her body, I posed the model in a location where there was some shade from two trees— one behind her and one in front of her. You'll notice that the elements around her (even her feet in the foreground and her supporting right hand in the background) are all brighter.

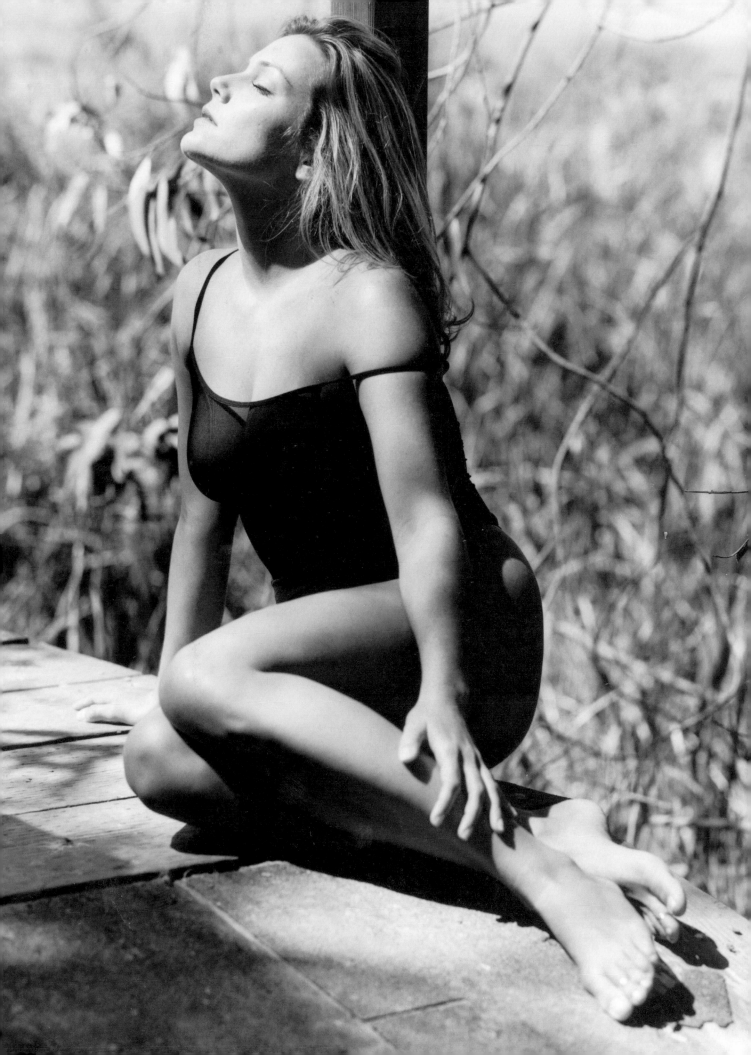

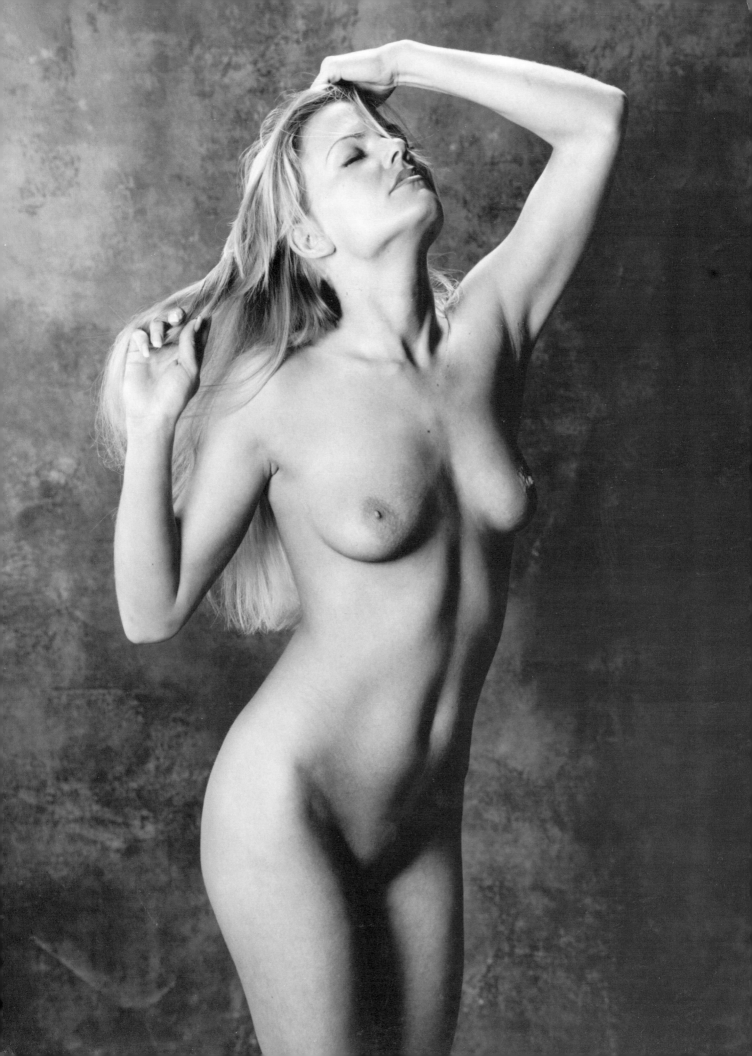

LIGHTING

⇥ CONCEPT

This image is a based on a shot by Ken Marcus, who used to shoot for *Playboy* and *Penthouse*. I decided to try it with my own model.

⇥ LIGHTING

The image was shot in my studio using a small umbrella as a hair light. This creates the rim light on her hair and forearm, helping to separate her from the backdrop. An 8"x36" strip light (basically a long, narrow softbox) was placed to the left of the camera to wash light over the side of the model's body. The lighting pattern this creates is actually quite discreet—showing the shape of her body but creating a dark V-shaped shadow over her lower abdomen. The model was posed against a painted black, olive and gold backdrop—a dark background that makes her body pop right out. Some light spills around behind the model from the strip light and illuminates the backdrop. This helps to define the shape of the front of her body (especially on her stomach and thigh) where it is in deep shadow.

CAMERA:
Bronica GS-1 (6x7)

LENS:
150mm

FILM:
Agfapan 100

⇥ POSING

I love the pose of this sensual image. It strikes me as very natural-looking—something that a beautiful young woman might actually do. The model's uplifted arms frame her face and also lengthen the appearance of her upper body. Shooting slightly from the side (rather than straight from the front) also makes her waist look very thin. Overall, the pose shows off her upper body beautifully. As you'll notice, the image is cropped just above the model's knees, since the lower body doesn't really need to be shown in this image. (If you keep your eyes open, you'll notice that most swimwear shots are cropped this way for the same reason.)

Model: Dori

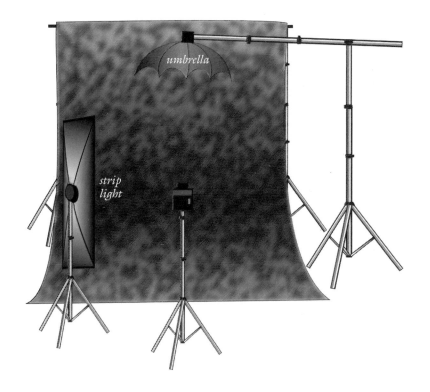

DEPTH OF FIELD

⇥ SETTING

This image was created in the doorway to my studio, at the entrance to the waiting room. In the background, you can see a display photograph hanging on the wall.

⇥ LIGHTING

An 8'x8' scrim was placed to camera left. This provided even lighting on the model from head to toe. Two strobes in reflectors were placed behind the scrim. One was about 6' off the floor, and one was about 2.5' off the floor. Again, shining these two lights through the scrim ensured that the light would not fall off anywhere on her body. An additional strobe was placed in the room behind the model to ensure that the walls would stay clean and white.

CAMERA:
Pentax 67

LENS:
165mm, f/2.8, with Tiffen SFX3 soft filter

FILM:
Agfapan 100

⇥ MODEL

This was my first time working with this particular model. She was raised in Europe and had a very open attitude toward the session. I asked her for a very sensual, "come hither" look—and this expression is part of what makes the photograph so successful. Rather than posing her completely nude, she was dressed in an open robe, which falls seductively from her shoulders as she leans against the wall. I felt this was more sensual a look than total nudity for this image.

⇥ DEPTH OF FIELD

As mentioned above, in the background, you can see one of my sample portraits hanging in the entryway. Because I wanted the emphasis of the portrait to be on the model, I opened up to f/5.6, throwing the back wall (and the other photograph) out of focus. If I had it to do over, I would have opened up even more and rendered the background even more out of focus. Viewer's don't seem to mind it, but I'd have liked the background to be just a little softer.

Model: Georgina

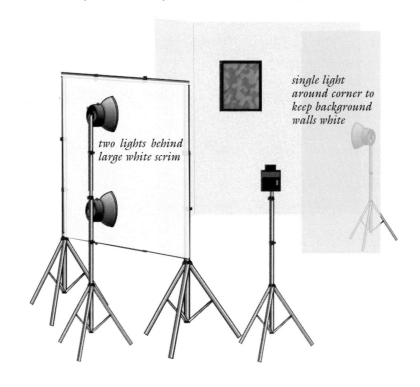

two lights behind large white scrim

single light around corner to keep background walls white

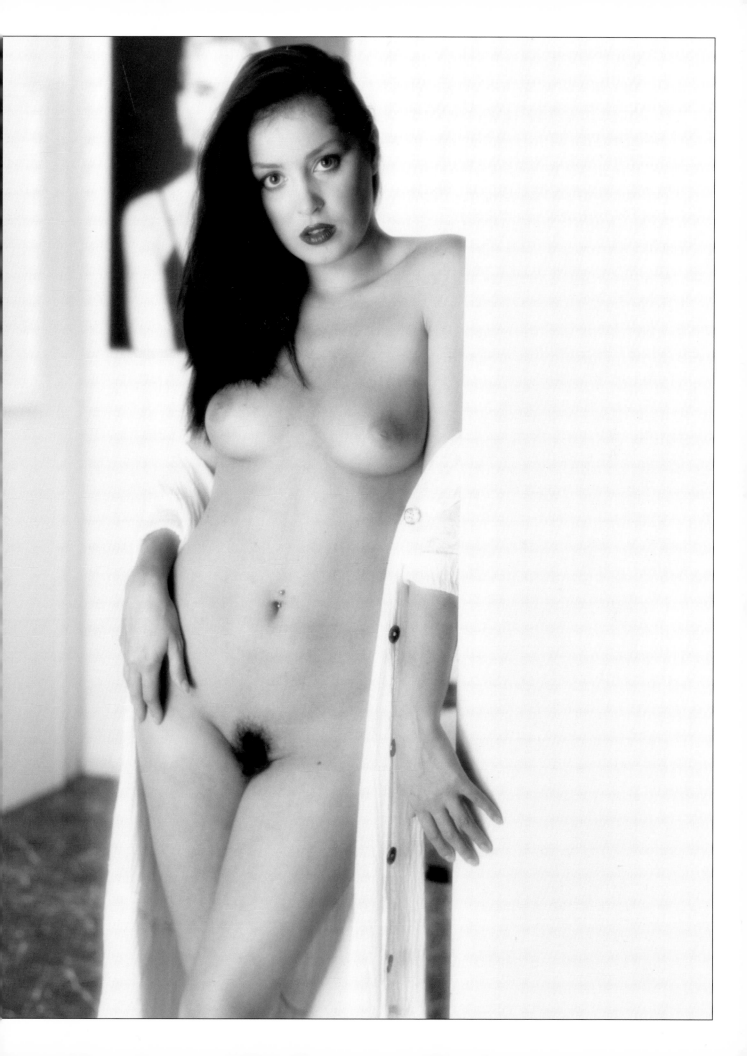

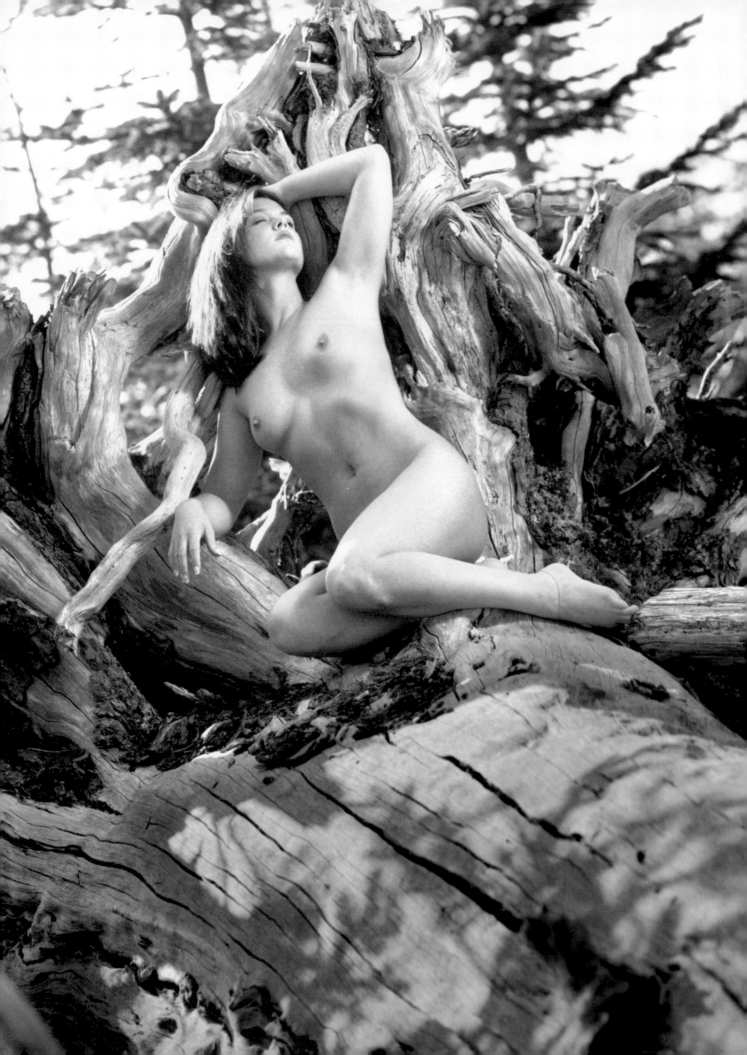

PRINTING

➥ **SETTING**

On an outing in Washington state with several models and another photographer, I noticed this beautiful formation of weathered roots from a tipped-over tree. I thought it would be an ideal background for a nude photograph. There was a natural open area among the roots, and I asked the model to fill this spot with her body.

➥ **POSING**

As you can imagine, it wasn't a particularly comfortable spot for her to pose, so we worked quickly through several poses. I was immediately happy with the way she had posed her lower body (as seen here), so we worked particularly with her upper body and arms. She posed with her arms up, and arms down. We were happiest with the pose you see here, where the model leaned back on one arm and lifted the other to her hair.

➥ **LIGHTING**

This photograph was shot with natural light and one reflector. The light was coming strongly from the left (note the strong highlight on the left side of the model's hair) and the reflector

was placed to the right of the model for fill light.

➥ **PRINTING**

The intensity of the light meant that, to get the proper exposure on the model's skin, the part of the tree in the foreground would be overexposed. This is one of the circumstances where custom printing is in order. If you don't print your own black & white, you'll need to find a custom lab or printer capable to do it for you in order to achieve an acceptable print in this situation. Here, the tree trunk in foreground was burned down significantly. This left the model's skin exactly as I had intended it, and eliminated what would have been a very distracting highlight area in the foreground.

Model: Brandi

CAMERA:
Pentax 67

LENS:
165mm, f/2.8

FILM:
Kodak TXP

S H O W E R

✦ SETTING

This photograph was created in the shower stall that is located on the upper level of my studio.

✦ MODEL SELECTION

Because I had a raised-arm pose in mind, I selected a shorter model. Had I done the image with a girl who was much taller than 5'6" or 5'7", her elbows would have extended too far above the shower head, making the photograph hard to frame the way I wanted it. Since the shower head was the fixed element, I had to make a model selection based on it.

✦ LIGHTING

As you can see, the main light source comes down from the top of the stall, toward the model's upturned face. The ceiling of the shower stall was unfinished, with the silver-backed insulation showing. This shiny silver material allowed me to bounce a strobe light off it effectively. The light was positioned outside the shower and simply aimed up at the ceiling over the model's head. I then metered the highlight area of the scene to determine the desired exposure.

✦ COMPOSITION

The model's body is neatly framed between the wall on the left side of the frame and the shower curtain on the right.

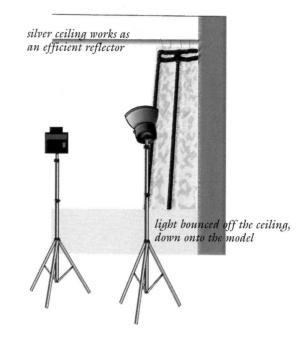

silver ceiling works as an efficient reflector

light bounced off the ceiling, down onto the model

The model's body, which is in the left half of the frame, is balanced by the strong, dark lines on the shower curtain in the other half of the frame.

✦ POSING

The model's pose is sensual, with her arms raised and her head high and back—as though she's washing her hair. Aside from the appeal of the pose, it also has the added benefit of elongating the model's body and lifting her breasts. This gives her a very toned, flattering appearance.

Model: Georgina

CAMERA:
Pentax 67

LENS:
165mm, f/2.8

FILM:
Kodak TXP

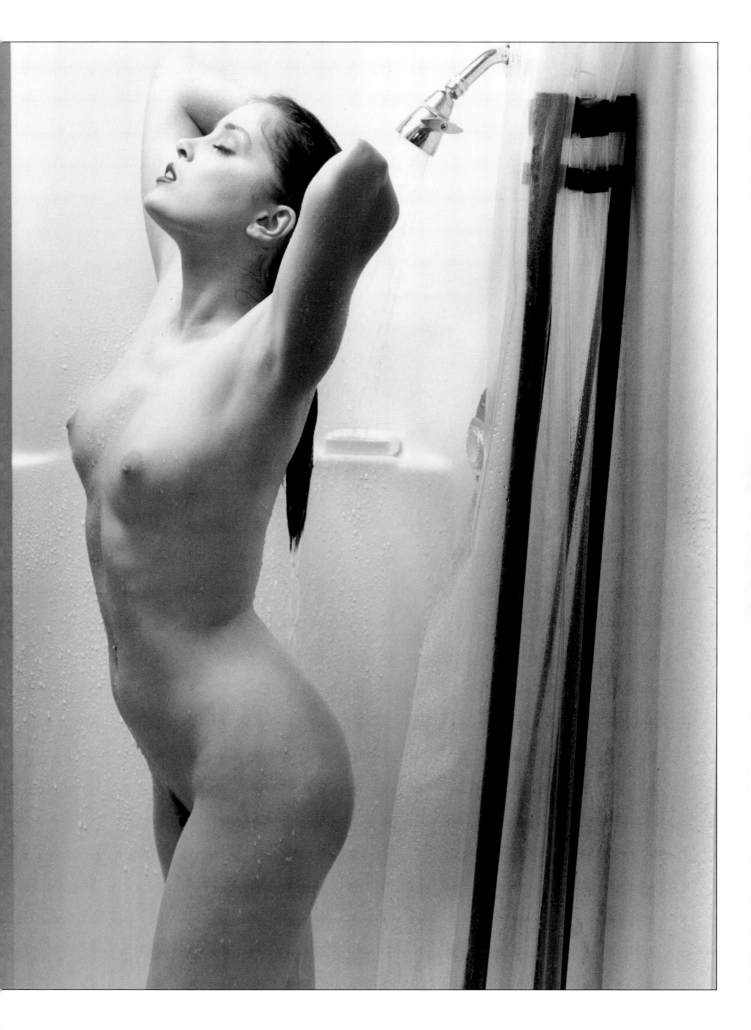

FASHION LIGHTING

●▶ SETTING

This model was posed in my headshot booth. This booth features a white seamless paper backdrop and a posing table. The posing table is an inexpensive drafting table, the top of which can be adjusted for angle and height. The tabletop is also covered with reflective silver material, so it bounces light up onto the face of the subject.

CAMERA:
Pentax 67

LENS:
165mm, f/2.8

FILM:
Agfapan 100

●▶ LIGHTING

The mainlight was a 44" white umbrella placed over the camera. This straight-on, fashion-style lighting provides minimal shadow formation for a very smooth, flawless look on the skin. It does, however, provide enough shadow to show the contours of the model's lovely bone structure. As noted above, the reflective top on the table at which the model is posed also bounced light up onto her upper body and face.

●▶ MODEL AND POSING

This model didn't want to show anything in her photographs. Allowing the open neck of her peasant blouse to drop off her shoulder created a look that is

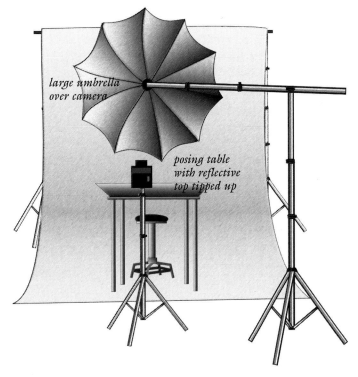

large umbrella over camera

posing table with reflective top tipped up

sexy, but not revealing. She is posed with her arms crossed—bringing her hands into the photograph and giving the image a little attitude. It is a much stronger composition than if she were posed with her arms down. Her arms, crossed under her chest, also help to lift her breasts and create a fuller-looking chest. The model's expression—the slight smirk in her eyes and on her lips—is the final touch.

Model: Sage

ILLUSION

Although you may have to take a second look to tell, the model is completely nude in all but the upper left-hand photograph (where she's wearing a towel and looking into a mirror. The other items of "clothing" in this sequence were all carefully created using body paint. Working left to right, top to bottom, in the second frame, we began painting on the model's "underwear," beginning with the bottoms. Next, a "bra" was added—then transformed into a camisole in the next frame. In the center frame, the model was outfitted with a painted-on dress. Long gloves were added in the next frame. In the final three frames, the model and artist had some fun with the paint, adding a tattoo on the model's ankle, and handprints elsewhere.

PAINT

When doing body painting, be sure to use a paint that is safe for contact with human skin and washes off easily. If in doubt, you can purchase specially formulated body paint. In this case, our stylist, Kelly Cazzaniga, selected a washable Crayola® paint. Before applying any paint, be sure to talk with the model to ensure that she hasn't had adverse reactions to paint (or other chemical products) in the past.

LIGHTING

For all the photographs in this series, a 4'x6' softbox was used to the right of the camera. A smaller softbox placed to the left of the camera provided fill light. A hair light was then added above the model.

CAMERA:
Pentax 67

LENS:
165mm, f/2.8

FILM:
Agfapan 100

Model: Rebecca

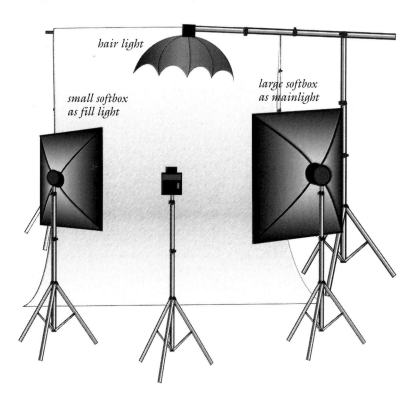

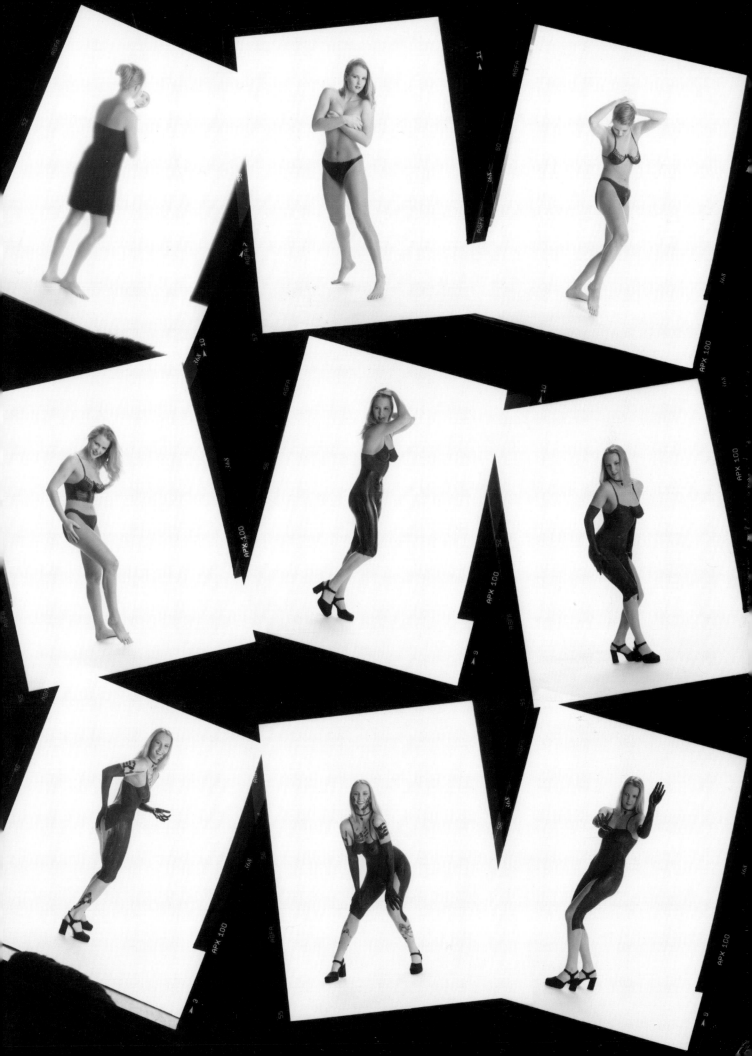

WATER

➤ WATER

Using water is an easy way to add a new element to your photography. Adding shimmer to the skin and a totally different look to the hair, water can totally change the character of a shot. In addition, water has a sexy quality to it—making subjects look as though they might have just stepped out of the shower or returned from a dip in the pool.

➤ LIGHTING

To create a soft lighting effect, yet maintain good contrast with nice highlights and deep shadows, two lights were used. The first light was a softbox, placed to the right of the camera, which created nice catchlights in the model's eyes and cast deep shadows on the left side of her face. A silver umbrella, with its crisp light, was positioned over the model as a hair light. This light source provides a nice degree of control, spilling light onto the model's head and shoulders, but not all over the place.

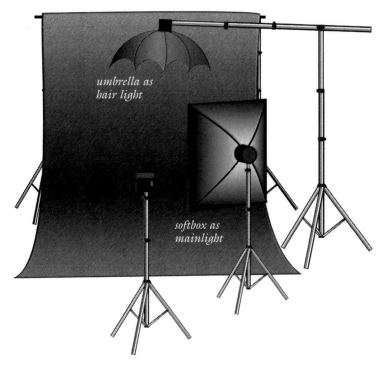

umbrella as hair light

softbox as mainlight

➤ MODEL AND POSING

The model was dressed in a strapless bathing suit top, appropriate for use with water. She was photographed standing against a black background. Her head was just slightly tilted to her right, making the pose a little warmer and vulnerable, and less rigid.

Model: Lindsay

CAMERA:
Pentax 67

LENS:
165mm, f/2.8

FILM:
Agfapan 100

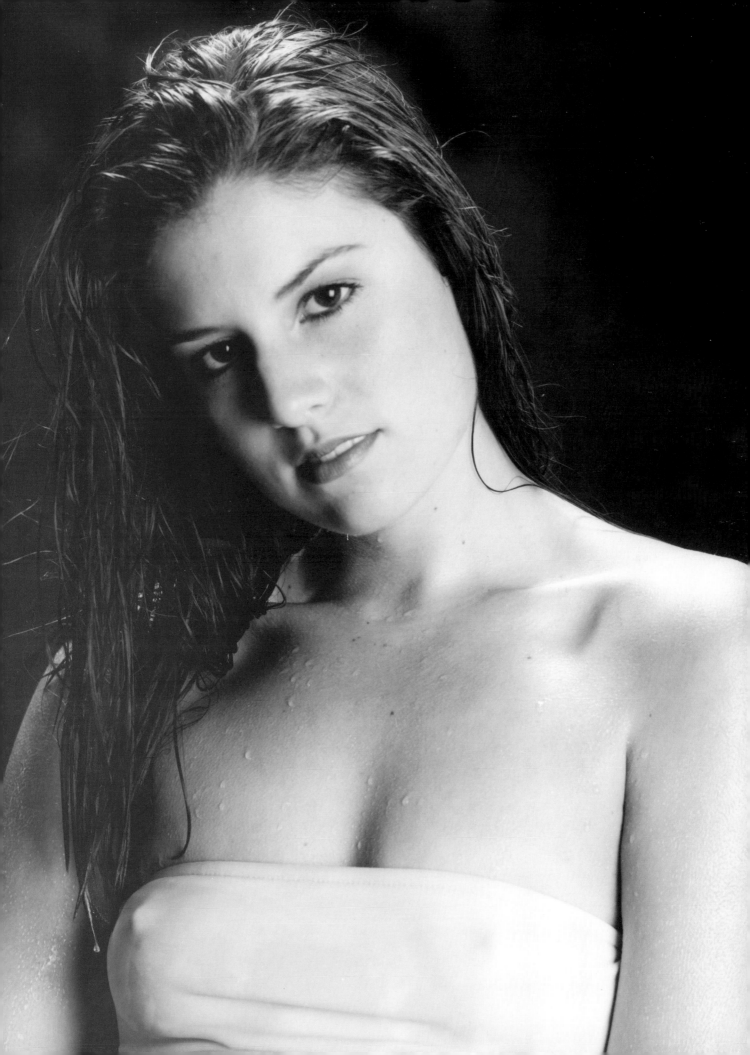

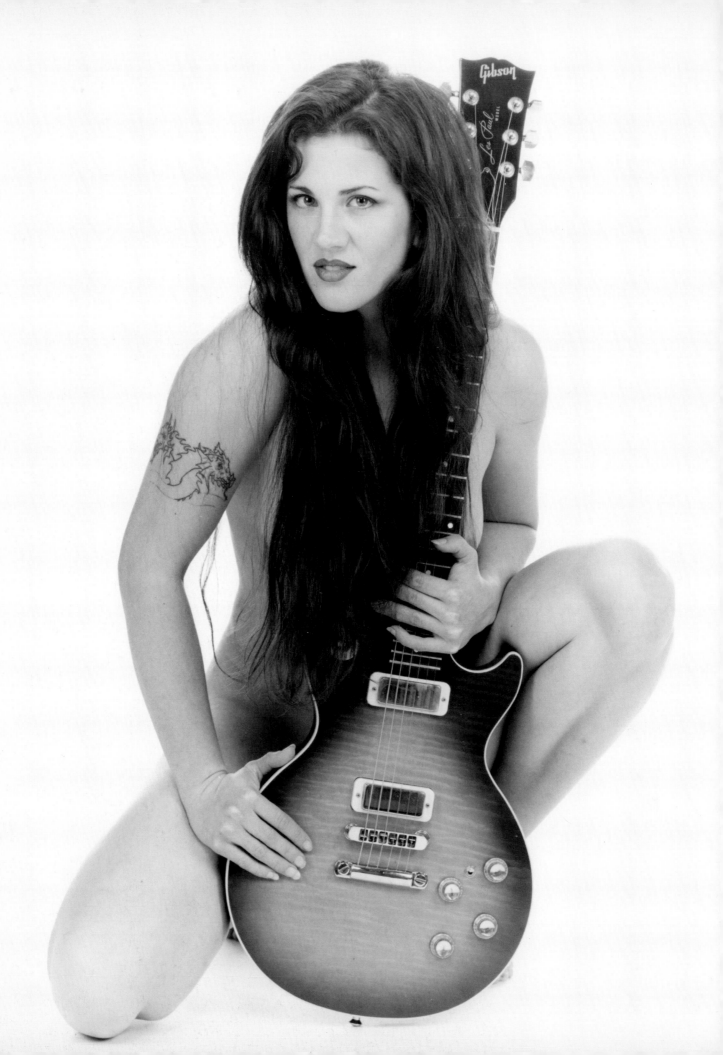

CD COVER

⤖ COLOR TO BLACK & WHITE

This image was originally shot in color, but its strong lines and composition make it work equally well in black & white.

⤖ ASSIGNMENT

This photograph was created specifically for use on a CD cover. The model was willing to do a nude image, but didn't want anything to show. Accordingly, she was posed using a guitar and her hair to cover most of her body. Her face, full of attitude, has just the right tone for the CD cover.

⤖ LIGHTING

Two medium softboxes were placed to either side of the camera. An umbrella was placed over the model as a hair light. Two lights were directed toward the backdrop. These were set to two stops brighter than the mainlight, assuring that the white seamless backdrop would be rendered as clean and bright.

⤖ RECORD-KEEPING

I'd like to catalog my work on the computer, and eventually I will. Now I store my negatives in #10 envelopes, labeled with

CAMERA:
Pentax 67

LENS:
165mm, f/2.8

FILM:
Kodak TMAX

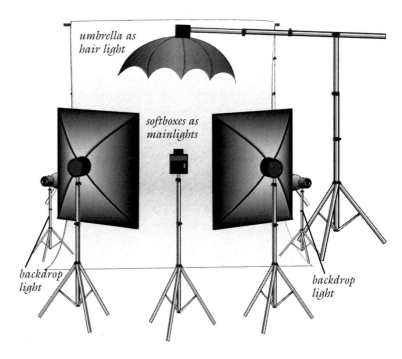

umbrella as hair light

softboxes as mainlights

backdrop light

backdrop light

the date the image was shot (month and year), who the model is, and what the shot is (headshot, nude, etc.). I then store the envelopes in the box the #10 envelopes come in. Then I have alphabetical index cards to keep the images in alphabetical order. I also have boxes with negatives for on-going and everyday projects. For instance, I have two boxes for current clients, and when I started working on this book, I created a separate box for images to be used in it. So far this system has worked very well.

Model: Sage

PLATFORM

→ LIGHTING

Two medium softboxes, placed on either side of the camera, were used to create this flattering portrait.

→ SETTING

The model was posed on a custom-built platform in my studio. The platform consists of a 6'x4' wooden base and top on rollers. It was built for me by a local cabinet maker, who did the work in exchange for family portraits. The platform stands about 28" tall and is a great surface on which to pose models, or even to shoot larger products. The extra elevation (as opposed to shooting on the floor) makes for a much more comfortable shoot. I add a 9'x4' sheet of plywood on top of the platform for shots where I want to use backdrop paper. The larger dimension of the plywood supports the full width of the backdrop paper without allowing it to droop. The platform is an extremely versatile tool that I would recommend to anyone. Here, I covered it with a sheet and added some pillows to create the look of a bed—but the possibilities are limited only by your imagination.

Model: Shannon

→ POSING

The model didn't want to do images that were too revealing, so she wrapped herself in a sheet for this shot. She then kneeled on the "bed" and leaned forward toward her raised knee. She faced directly into the camera for a portrait that emphasizes her beautiful face.

→ COMPOSITION

The model was wrapped in a black sheet and posed on the platform covered with white sheets. Therefore, adding a black pillow at the top of the "bed" was important for creating a balanced composition. In the pose, her arms and leg create strong diagonals that lead your eye to her face.

CAMERA:
Pentax 67

LENS:
165mm, f/2.8

FILM:
Agfapan 100

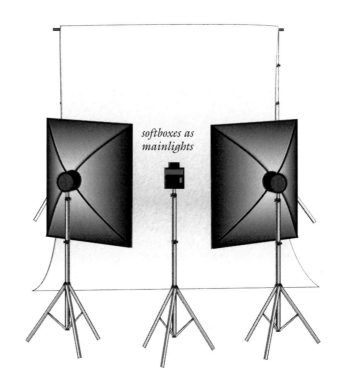

softboxes as mainlights

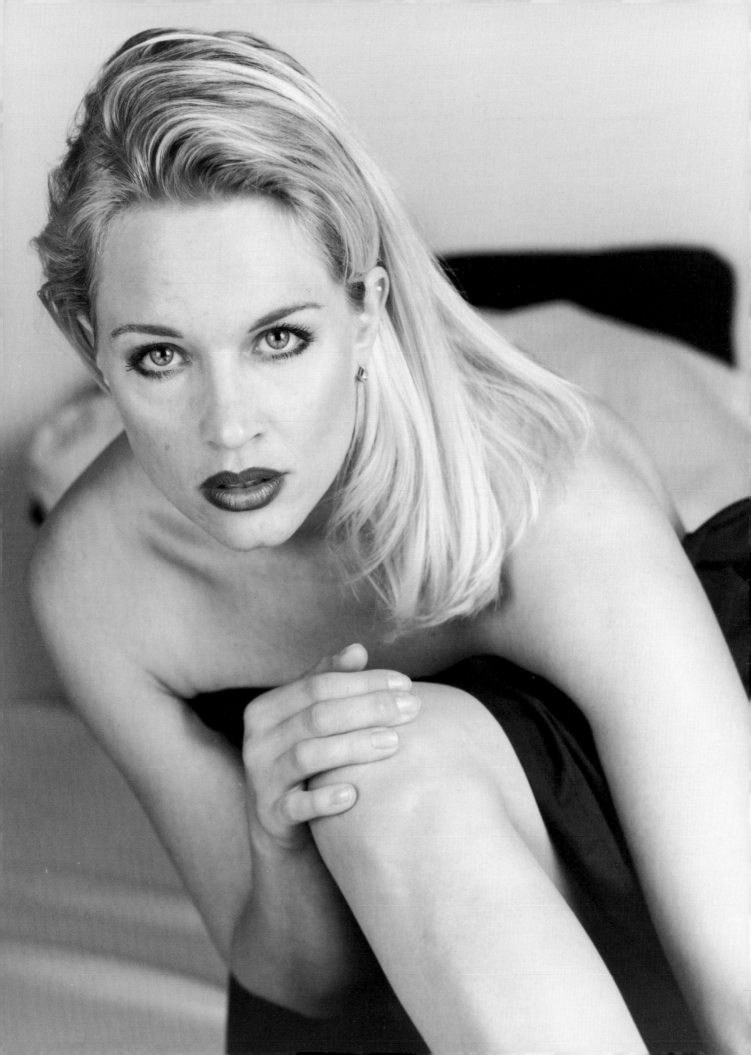

CAMERA ANGLE

POSING

This model has an all-around great body, so I wanted to create a photograph that would show it off from head to toe. With her feet apart, the model's hip is swung to the side to emphasize the length of her legs. As you can see, the model's right leg looks especially long due to the hip shift. Next, her arms were raised over her head. This not only frames her beautiful face, but also lifts and elongates her upper body, making her look even taller and more toned. Her entire body faces into the light to further emphasize her beautiful skin tone with soft frontal lighting.

CAMERA:
Hasselblad 503cx

LENS:
150mm

FILM:
Kodak TMX 100

LIGHTING

We shot this portrait late in the day (six or seven o'clock in the afternoon) for two reasons. First, the image was also shot in color, and I wanted later daylight for the golden, glowing color it adds to skin tones. Second, the lower angle of the sun provided even illumination over her body. This could also have been achieved in the morning, but not in this location—the side of the tractor where I wanted to shoot would have been in shade at that hour. The model was posed with her face toward the sun to ensure that her face would be properly illuminated with only very light, open shadows.

CAMERA ANGLE

For this shot, the camera was placed at a relatively low angle. This contributes positively to the image in two important ways. First, shooting up at the model further elongates the appearance of her body, making her look even taller. Second, lowering the camera improves the composition by allowing the background to fill the frame properly without creating problematic intersections between the background and the model's body.

POSING

Notice that the horizon line falls below the model's hip in this image. If I had shot from a different angle, that line would have crossed her body at a different place. It's important to keep strong horizontals (such as the horizon) from intersecting with key points of the body, like the eyes, neck and waist. A lot of people don't pay attention to this easy-to-correct problem, and the result is images in which the model's body seems unnaturally segmented and broken up. If you are trying to create a long, slim look like the one featured here, the effect of a distracting horizontal line can sabotage your image if you aren't careful. Again, simply adjusting the camera angle can normally fix this problem with minimal fuss.

Model: Dale

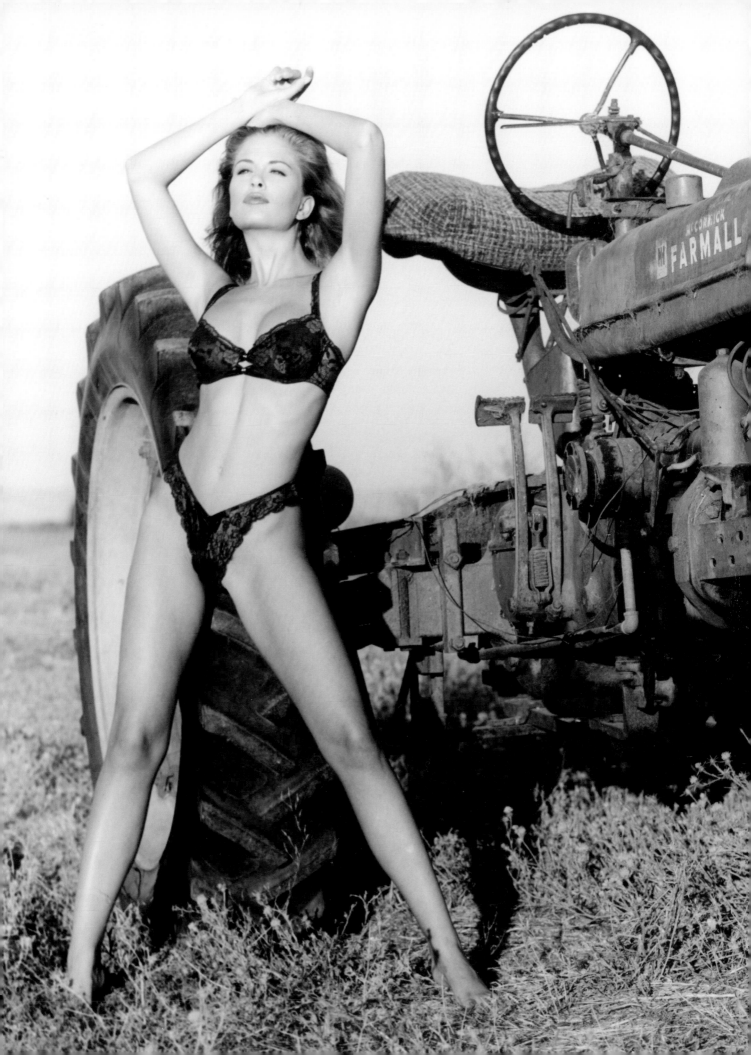

HARSH LIGHT

↠ POSING

This image concentrates on the model's face and upper body. The model was posed leaning back against a large steel drum, the rough texture of which makes her skin look all the more smooth and even. The model's long hair was swept to one side and allowed to fall over her chest and shoulder. Notice how the sweep of hair frames her face. Posing the model with her head tilted and eyes closed creates a softer and more intimate mood.

↠ CLOTHING

Rather that do this image as a full nude, the model wore a white top that was unbuttoned and allowed to fall open. In this case, the clothing was added more for the sake of composition than modesty. The strong white lines of the open top serve to set off her body from the background, and create two diagonals that keep your eyes confined to the model's body.

↠ LIGHTING

The light in this open area of the field was extremely harsh. To break up the light for a softer look, a scrim was placed to the left of the camera.

↠ METERING

Using an incident light meter, I took a reading from the model's face, since the skin tones were the most important part of this image.

CAMERA:
Hasselblad 503cx

LENS:
150mm

FILM:
Agfapan 100

Model: Kirsten B.

HINTS AND TIPS

Experience will help you make accurate exposure decisions, but in tricky situations a Polaroid® can also be extremely useful. If you're not sure, you're better off safe than sorry. Shooting a Polaroid® also has additional advantages. You can shoot a Polaroid® in black & white for a quick preview of the image without the color. This can help quickly identify problems, such as areas where the skin and background are too close in tonality to provide good separation. This is much harder to evaluate in color. A Polaroid® can also help you to evaluate the contrast and composition. Seeing a Polaroid® is a great way to check for distracting elements, problematic horizon lines and other elements that can be more obvious in a print than in your viewfinder. Finally, a Polaroid® can be a useful tool for working with models, since you can show how the pose looks and work with them to fine-tune it with a shared point of reference.

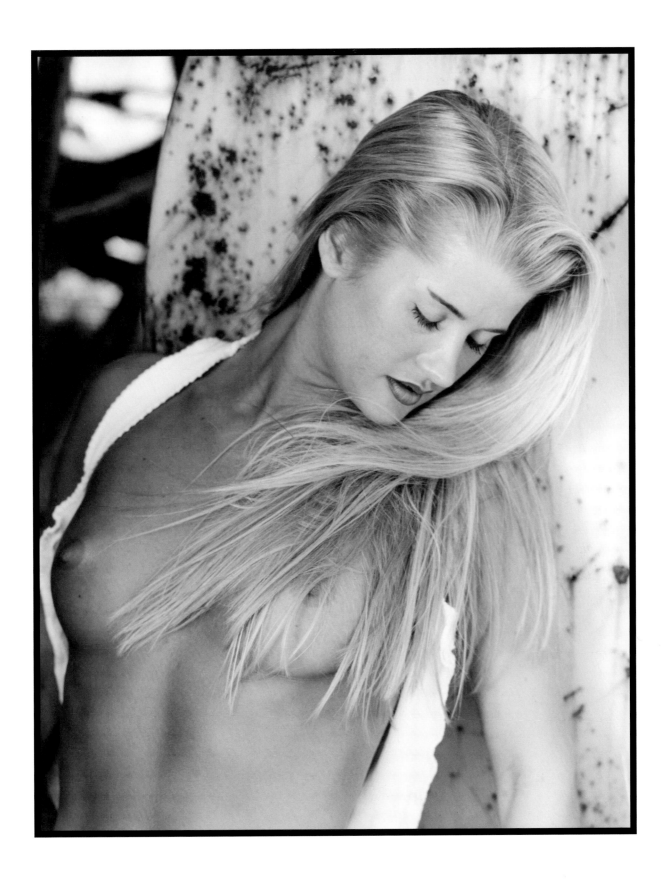

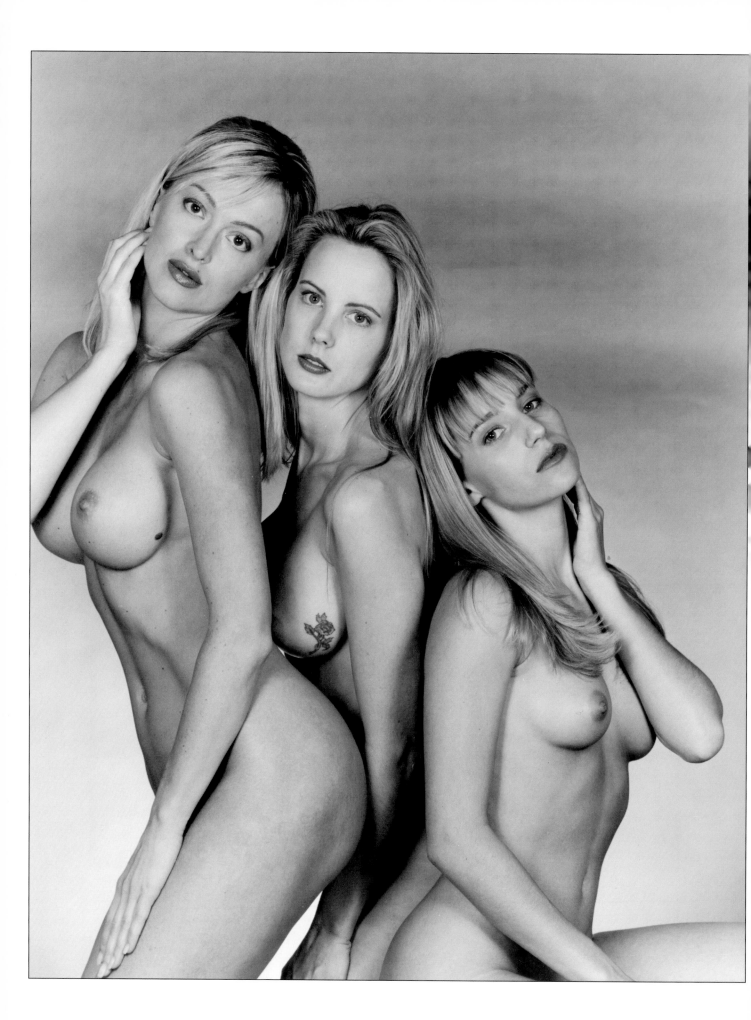

TATTOOS

⇥ SETTING

This image was taken in my studio against a gray background. I had seen an image similar to this, and wanted to do my own version. After a long session working with a group of models, I asked these three if they'd like to stay to work on this image.

⇥ LIGHTING

Two softboxes were placed to the right and left side of the camera. A backlight was directed at the background to provide separation between the models' bodies and the backdrop. This is especially visible on the stomachs of the two flanking girls. Unfortunately, while we were setting up, someone kicked the background light over and never mentioned it. As a result, more light falls on the left than the right side of the frame.

⇥ POSING

I began posing the three models with the girl on the right, who is seated on a posing stool. Working to the left, the next model is almost squatting and positioned back-to-back with the seated model. The final girl was posed with her knees bent slightly, fitting her body against the model behind her.

⇥ COMPOSITION

The arms and hands are what makes this image so strong. The three models' faces are aligned on a diagonal that is framed on either side by an uplifted hand to the model's cheek. The models' forearms all create diagonal lines that add interest throughout the

CAMERA:
Pentax 6x7

LENS:
200mm

FILM:
Kodak Plus-X
at ISO 100

frame. If I could change one thing about this photograph, it would be the fact that the elbow of the model on the left is cut off.

⇥ TATTOOS

Some people feel I should have airbrushed out the rose tattoo which appears on the breast of the girl in the center. However, I feel that tattoos and body piercing are so common today that you have to learn to live with them, rather than always trying to eliminate them. In this case, placing the tattooed model in the center of the frame helped to reduce the distraction and maintain a balanced composition.

Models: Malinka, Michelle and Kirsten H.

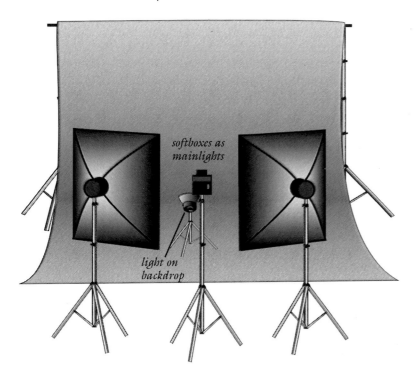

softboxes as mainlights

light on backdrop

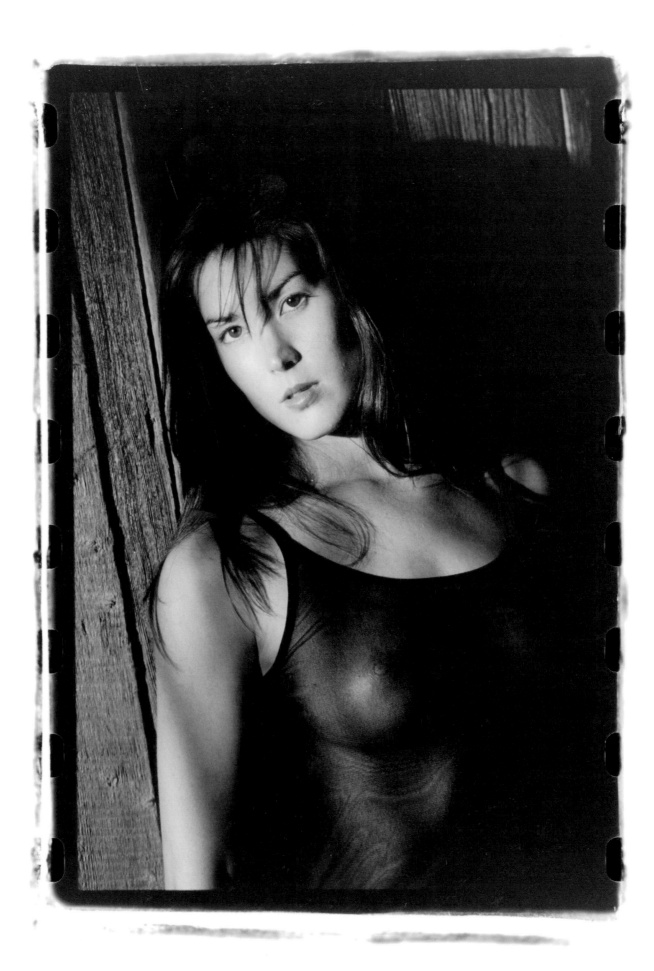

TUNGSTEN LIGHT

⇥ EXPRESSION

This is a very beautiful and unusual-looking model, who has both Caucasian and Asian influences in her family tree. I wanted to create a portrait that showed off her unique beauty by focusing on her face, but also revealing her body in a restrained way. I asked her for a sensual look, and was rewarded with this deep and intense expression.

⇥ POSING

This was my first shoot with this model, so we kept the set and posing quite simple. The model leaned up against a barn board wall in my studio. She was dressed in a sheer black dress that provides some coverage and comfort, but also allows her chest to show subtly though the fabric. This sensual look leaves just enough to the imagination.

CAMERA:
Nikon FM

LENS:
80–200mm

FILM:
Kodak TMX 100

⇥ LIGHTING

I used a single tungsten light for this image. Because it is a continuous light source, this allowed me to precisely control the lighting effect. To break up the light and create a dappled effect, a potted palm was placed in front of the light.

This creates great texture and shadows on the model's body. Once in place, the palm was adjusted so that light fell precisely where I wanted it. In this case, the light was adjusted to fall primarily on her face, and to a lesser degree on her upper body. This puts the focus on her face, and creates a secondary area of emphasis on her chest.

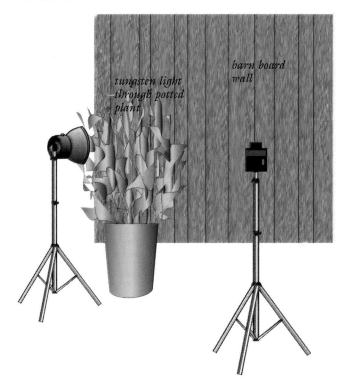

tungsten light through potted plant

barn board wall

⇥ FINISHING TOUCHES

The camera was tilted slightly for this image, creating diagonals throughout the frame. The image was also printed with a rough border that suits the rough look of barn boards in the background.

Model: Shanti

FACE ON HAND

➻ LOCATION
This moody portrait was shot in Washington state. Daylight was the only source of light, but the shooting area was in shade, so the light was broken up and very soft. In fact, it was the great light in this spot that inspired the portrait—it was just too beautiful to pass up!

CAMERA:
Nikon FM

LENS:
28–200mm

FILM:
Kodak Tri-X
at ISO 400

➻ POSING
The model was seated on a rock and placed her elbow up on another rock. She leaned slightly forward toward the camera, and pushed her hair forward over one shoulder. The hair cascades down her body and conceals one breast—making the image still nude, but definitely more discrete. This was something the model was concerned about.

➻ FACE ON HAND
Whenever a model's face is propped up on her hand, it is important to make sure that the model doesn't actually place any weight on the supporting hand. Doing so will cause the line of the cheek and jaw to become unflatteringly distorted. In this case, the model's hand is also just slightly too far forward; it should have been positioned farther back, a little closer to her neck.

➻ EXPRESSION
The model's expression is what makes this image so engaging. The look is moody, yet direct. The model's barely-parted lips add a bit of sensuality, which is echoed by her bare breast.

Model: Vicki

HINTS AND TIPS
If you plan to have your model's lips open any more than this, be sure that her teeth are visible. Depending on the model and her facial structure, they may or may not be visible with the lips parted. As a rule of thumb, if the lips are open, the teeth should show.

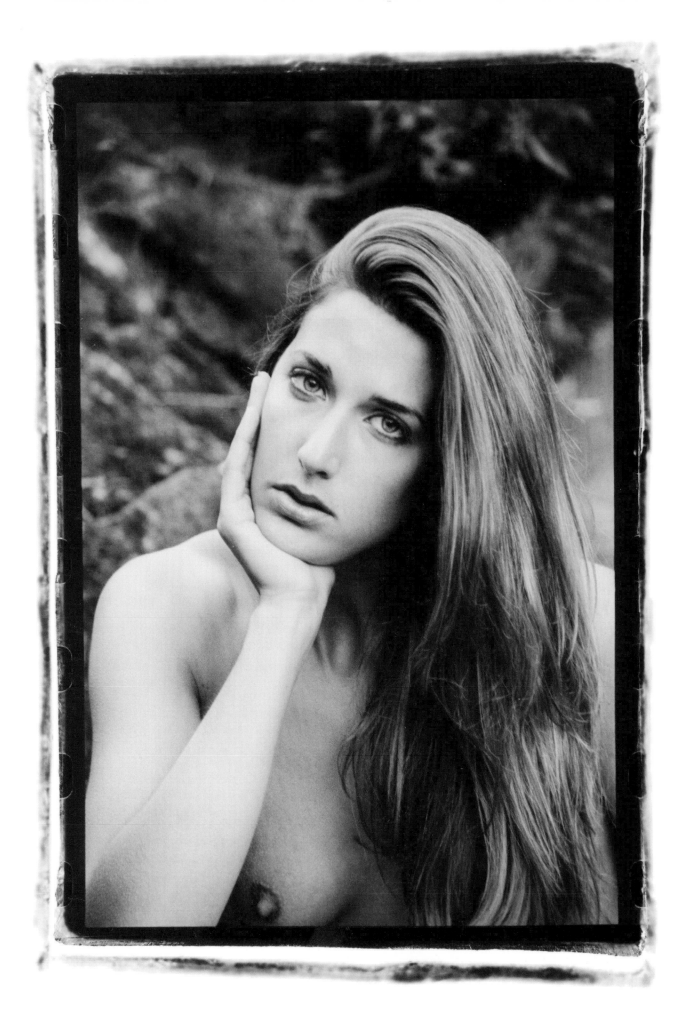

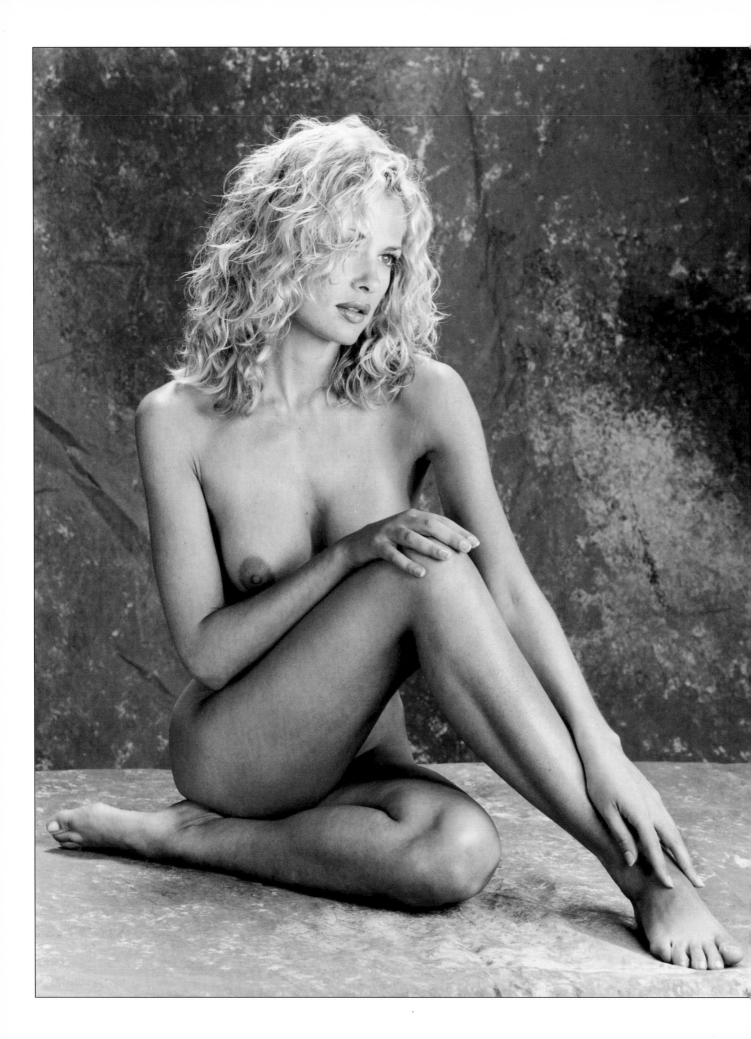

STUDIO POSING

→ SETTING

This photograph was taken in the studio against a painted canvas backdrop. The model was seated on a posing platform, and the backdrop was draped across it.

CAMERA:
Pentax 6x7

LENS:
165mm, f/2.8

FILM:
Agfapan 100

→ LIGHTING

Three lights were used to create this image. Two softboxes were used as main lights and placed side-by-side to the right of the camera. A 22" silver umbrella was used as a hair light above the model. This emphasizes the wonderful texture of the model's hair and makes it a focal point in the image.

→ POSING

This pose was selected by the model. She is a very soft and feminine woman, so the pose suits her very well. Folding her legs underneath her completely hides the crotch area, while emphasizing her long, elegant legs and arms. The pose reveals a little breast, but is fairly modest, all in all. For a non-nude variation, pose the model with her upper body turned slightly toward her raised knee, and you'll create a pose that reveals nothing

more than a bathing suit. This pose is especially well suited to showing off the hands of a model with graceful ones. As you can see here, the model's hands are extremely feminine and they drape softly on her knee and ankle. The fact that the model is not looking into the camera creates an added sense of romanticism.

→ COMPOSITION

This composition features a number of nice angles and diagonal lines. Notice how the bends of the right elbow and knee are equal. This helps to pull the image together. The left arm and leg come together in a similarly coordinated way.

→ GUESTS ON THE SHOOT

When I schedule a shoot, whether on location or in the studio, I don't place any restrictions on the model

bringing a friend along. The only thing I don't like (and discourage) is models bringing along a boyfriend or husband. It's not that I feel that they'll get in the way, but more that it makes me feel less relaxed and less able to create the images I want from the shoot. An important factor in my images is the focused artistic relationship between the model and the photographer. With a boyfriend or husband on the set, this gets lost to some degree since the model may feel self-conscious or look to him for approval. With female friends there doesn't seem to be the same problem. Ultimately, I prefer a one-on-one shoot, and since most of my models come to me through referrals from other models, they don't usually mind coming alone.

Model: Dale

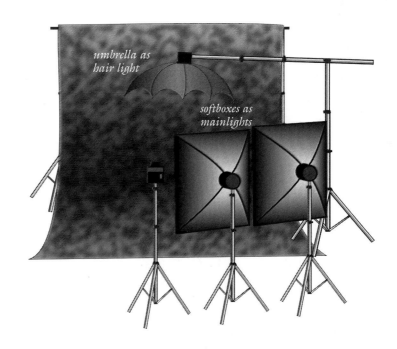

umbrella as hair light

softboxes as mainlights

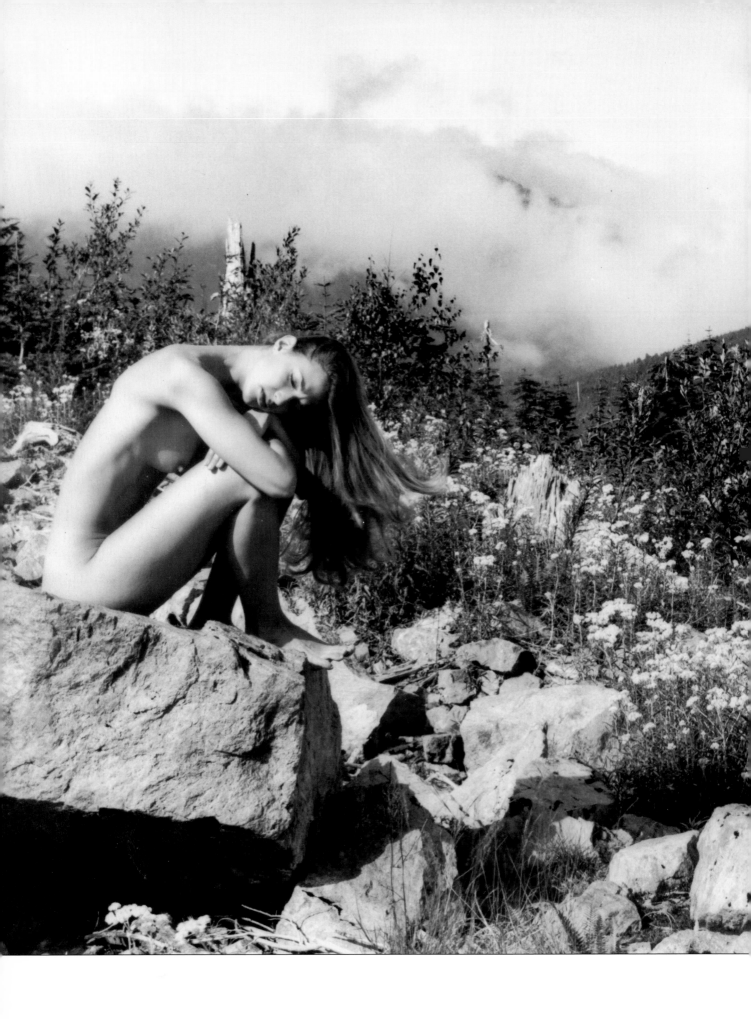

See full image, pages 36–37.

❖ SETTING

Taken on a mountaintop in Washington state, this image combines two natural beauties: the model and the landscape. In our four-wheel drive vehicles we climbed to this spot— one of the first ones we visited on a full day of outdoor shooting. With the fog in the valley below and Mt. Baker standing off to the right, this location was too beautiful to pass up. The image was shot fully nude to emphasize the "natural" character of the photograph. Perhaps the viewer will imagine that the woman has hiked up to the top of the mountain and, all alone in nature, decided to sunbathe on the warm rocks.

CAMERA:
Pentax 67

LENS:
75mm, f/4

FILM:
Agfapan 100

❖ COMPOSITION

My goal was to compose the shot in a very wide angle, allowing as much of the background as possible to show around the model. After evalu- ating the scene, I decided that the best place to put the model would be on the left side of the frame, where her body in the foreground would balance the image's composition.

❖ LIGHTING

Sunlight was coming from behind the camera position. I wanted some separation between the model's upper body and thighs, so I asked her to lift her chest slightly away from her leg. This allows the light to outline her breast. Her head and face were also turned into the light.

Model: Vicki

SILHOUETTE

➼ SETTING

I wanted to shoot a silhouetted nude of a woman in a doorway, and began to look around my studio for a place to shoot it. This particular doorway provided the perfect spot, with the louvered window on the left adding an extra area of interest. Because I wanted the cracked floor to show, adding texture and tying the image together, I prepared the area for the shoot by removing carpeting and paper from the floor.

CAMERA:
Pentax 67

LENS:
75mm, f/4

FILM:
Agfapan 100

➼ MODEL

Because I wanted the model's body to fill the door frame, I intentionally selected a tall model. Because she is 5'11", the model's head is relatively close to the top of the door frame, and doesn't leave too much unfilled white space in that area.

Model: Nicole

➼ POSING

We worked on many different poses, but focused on profile views to show the shape of her body. The model's bent knee helps to create definition and separation between her legs; her arms are posed to the same effect. Her slightly arched back and lifted chin help to elongate her body and emphasize its curves.

See full image, pages 36–37.

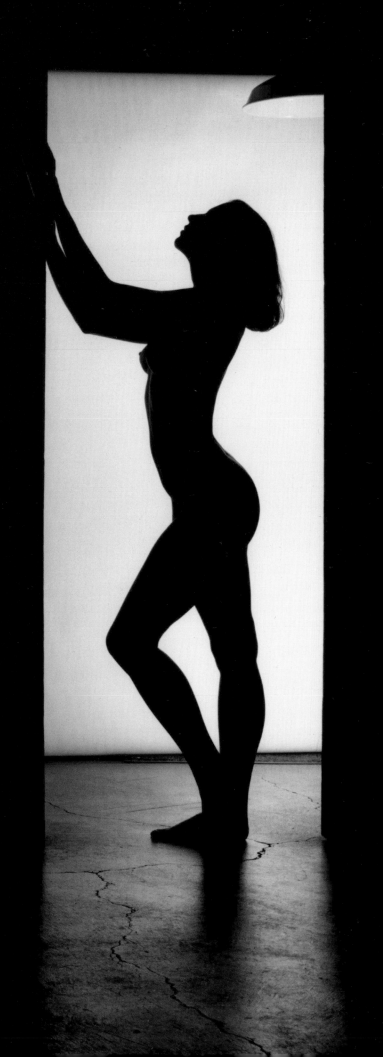

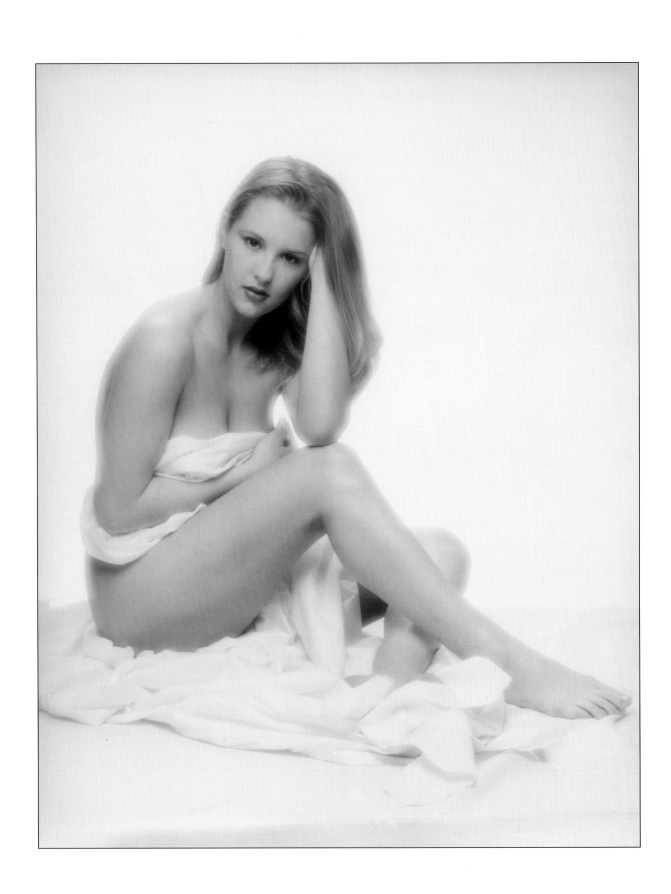

FILTRATION

SETTING

This photograph was shot in my studio on a raised platform where the model was seated. This was a very low-key shoot. The attitude and energy of the model always effects the character of the images that will be produced. In this case, the model was feeling more relaxed than energetic. The shots that resulted were, accordingly, very tranquil.

FILTRATION

To further soften the portrait, I used an SFX3 soft filter. Because I also wanted to maintain good contrast in the shot, I also added a yellow #2 filter.

CAMERA:
Pentax 67

LENS:
165mm, f/2.8, with Tiffen SFX3 soft filter

FILM:
Agfapan 100

POSING

The model for this portrait has a very nice body, but didn't want to show anything. Because of this, we worked on a pose that would show off her figure without being too revealing. A simple sheet solved the problem, creating an image that looks nude, but isn't. In her seated pose, the model's right leg was lifted slightly, with the foot elongat-ed, and the sheet pulled across her body. This exposes as much of the leg as possible, creating a long, flattering line. The model's right arm is under her breasts as she leans slightly forward, emphasizing the cleavage that shows above the bedsheet. The pose is very natural and relaxed in character—you can image a young woman actually sitting in bed like this, perhaps talking with her boyfriend or husband.

LIGHTING

Two lights were used to create this portrait. A 42" umbrella was placed above the camera, and a second 22" umbrella was used as a hair light above the model. I selected white umbrellas for the softer quality of the light they provide. While the crisper, harsher light of a silver reflector can work well for portraits of men, I prefer the softer look of white umbrellas for women.

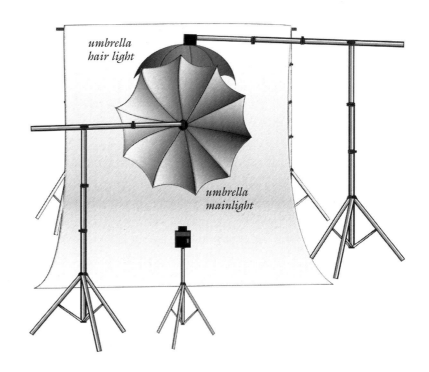

umbrella hair light

umbrella mainlight

Model: Rebecca

OUTDOOR POSING

↦ SETTING

This image was photographed on a stream in Washington state. The tranquil setting and water seemed like an ideal spot for nude images. The lighting in the area we chose was also soft and beautiful. The models were posed down in the stream bed, while I stayed up at the road and shot down from a bridge.

↦ POSING

Because the models were so far away, another person was stationed about halfway between them and me. I would yell instructions to him, and he would shout them to the models. We tried several variations with the two models closer together at this scene—one girl sitting, the other standing, etc. We finally decided that the setting worked best with the girls posed separately and with some distance between them. Both of the girls are posed with downturned faces and in relaxed positions that contribute to the tranquility of the image.

↦ SHUTTER SPEED

In order to slow the water down slightly, I shot this image at a relatively slow shutter speed—about $\frac{1}{8}$ second.

↦ COMPOSITION

This frame is full of texture from edge to edge. As a result, your eye has to wander a bit before you see the two girls. To help direct your gaze to them, the image was composed so that all of the other elements draw you into this central area of the frame. Leaving the models small in the frame adds an almost mythological quality to the image—allowing viewers to imagine that they have perhaps stumbled upon two nymphs about to bathe in the tranquil stream.

CAMERA:
Pentax 6x7

LENS:
165mm, f/2.8

FILM:
Agfapan 100

Models: Vicki and Brandi

PROFILE

⟶ INSPIRATION

This portrait was created during a shoot in which we were doing assorted headshots for this model's portfolio. While we were working on another image, I suddenly noticed her profile. It was soft and beautiful, and I decided we should do some photos of it.

⟶ POSING

Because the model did not wish to do nude work, she was posed in a tube top, revealing her beautiful neck and shoulders. For the shot, the model was seated at a posing table in front of a painted canvas backdrop. Her body was turned to a $^3/_4$ view away from the camera, while her face was turned slightly back toward the camera for a perfect profile. Turning the body away slightly creates a much more flattering portrait than rendering it in profile along with the face.

⟶ LIGHTING

Two lights and one reflector were used to create this portrait. The mainlight was a 42" white umbrella placed directly over the camera. A 22" silver umbrella was used as a hair light above the model, to accent the texture of her hair. The reflector used in this shot was attached to the top of the posing table, and angled up at the model's face to open up the shadows.

Model: Loriana

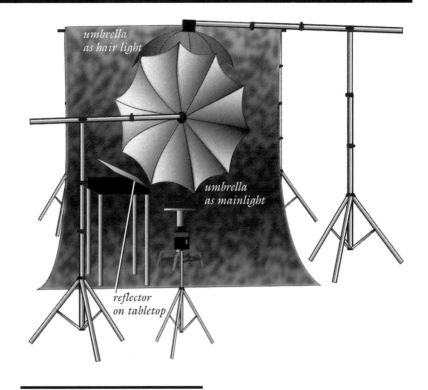

umbrella as hair light

umbrella as mainlight

reflector on tabletop

CAMERA:
Pentax 67

LENS:
165mm, f/2.8

FILM:
Agfapan 100

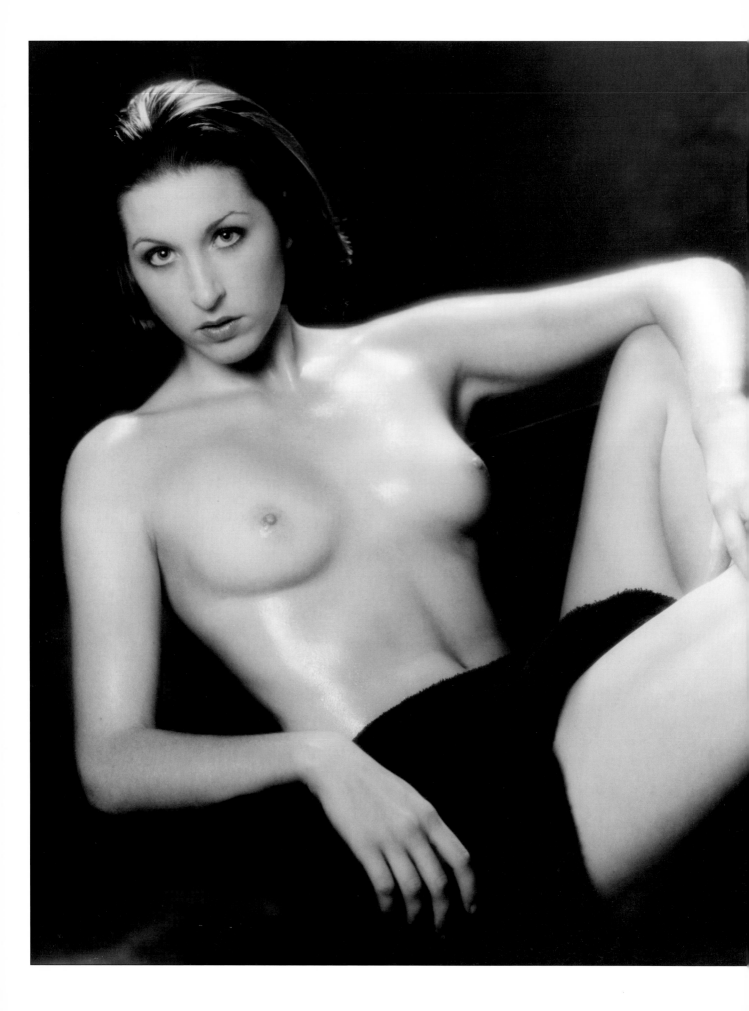

GLIMMERING

→ POSING

The model was seated in a black director's chair for this image. I wanted a more dramatic shot, so I had her lean on one arm, and swing her leg up over the other arm of the chair. This model has great legs, so this was a way to show them off, rather than cut them out of the frame—as they would have been in a regular seated position. The look—emphasized by her expression—is powerful and intense. Her relaxed hands, however, soften the image just slightly.

→ TOWEL

A black towel was draped across the model's hips for modesty. It also coordinates effectively with the "wet" look of the image, creating the impression that the woman has, perhaps, just finished working out.

→ LIGHTING

Two lights were used for this image. The mainlight is a 42" white umbrella placed in front of the model, and slightly to the right. A 22" umbrella was positioned above and behind the model as a hair light and to provide separation.

→ GLIMMERING

I wanted the model's skin to glimmer, so her body was covered with suntan oil (which smells better than baby oil and creates the same look). Her hair was slicked back to match the "wet" look of her body.

→ FILTRATION

Two filters were used on this image. The first was a #2 yellow filter to boost the contrast. The second was a SFX3 soft filter, used to create a moderate amount of softness that leaves her face quite sharp, but makes her oiled skin seem to glow.

CAMERA:
Pentax 6x7

LENS:
165mm, f/2.8

FILM:
Agfapan 100

→ CONCEPT

In most cases, the concept for a shot begins with the model herself. I think carefully about the model, and formulate tailored ideas to show off her best features. This model, with her dark hair and eyes, looks dramatic to me, so I tried to convey that in the photograph. This same photograph wouldn't be at all suitable for a blonde model, though—each image must be tailored to each individual.

Model: Nicole

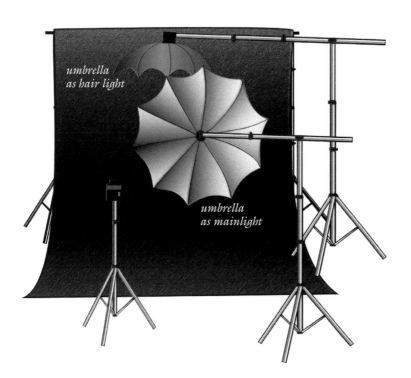

umbrella as hair light

umbrella as mainlight

SEPARATION

⇥ SETTING

Believe it or not, this image was created in a hotel room. It just goes to show that you don't necessarily need a studio to create the look of a studio image. When this photo was taken, I was teaching workshops in Virginia, and shooting models back at the hotel in the evening. Here, a piece of black backdrop fabric was taped to the wall, then draped down and across the bed.

⇥ POSING

This model has a really cute face, so I wanted to focus on that. She was posed laying across the bed and propped up on one arm. As noted previously, with poses like this, be sure to advise the model not to rest her cheek heavily on her palm, since this can distort the shape of the jawline.

⇥ LIGHTING

Two lights were used to create this image. A softbox was placed to the right of the camera and serves as the mainlight. A grid spot was placed to camera left and directed at the backdrop to provide separation light.

CAMERA:
Pentax 6x7

LENS:
165mm, f/2.8

FILM:
Kodak TMX 100

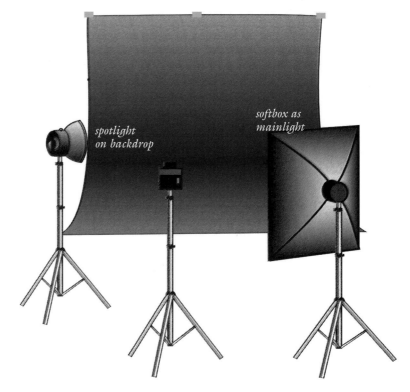

spotlight on backdrop

softbox as mainlight

⇥ SEPARATION LIGHTING

When photographing a model with dark hair against a dark background, it is especially important to provide ample separation lighting. If this is not done, the dark-on-dark tonalities can cause a loss of definition between the hair and the backdrop.

⇥ COMPOSITION

Once the issue of separation has been taken care of, you can see how the dark-on-dark image creates mood in the photograph. It is an especially effective technique in cases such as this where the face (the part I wanted viewers to focus on) is the lightest part of the frame. This means that, appropriately, it is the first thing viewers will see when looking at the image.

⇥ NUDE

This pose is a very modest and flattering one. While you can clearly tell that the model is nude, very little skin is actually showing. For models who want to create a sensual portrait, but are nervous about nudity (or don't have the figure for it), this is a great option.

Model: Sabrina

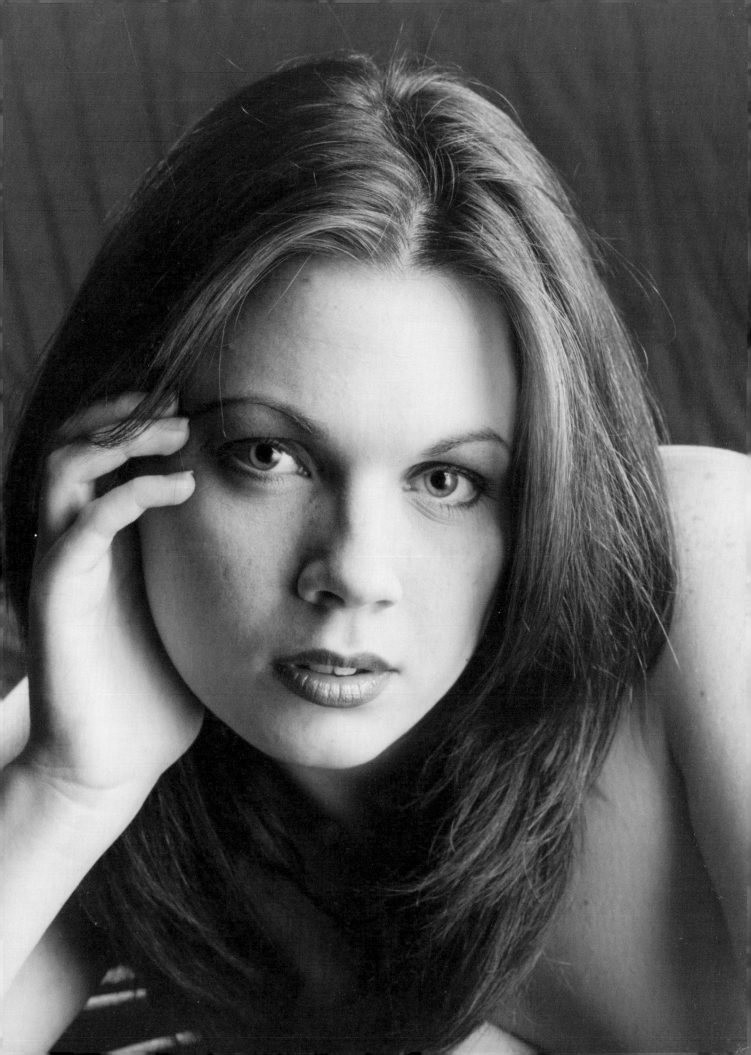

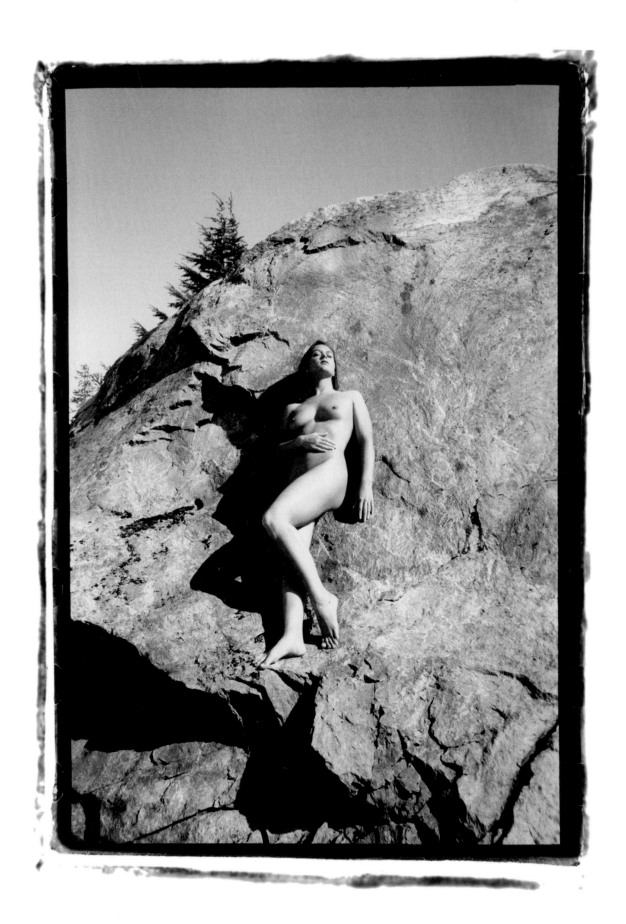

MODESTY

►► SETTING

This image was created on a photo expedition in Washington state. I had seen other photographers' images of nudes on rock formations. So when we drove by this site while en route to another shooting location, I decided to give it a try. I love the sharp contrast between her body, the deep shadows and the rough rock.

►► POSING

I simply had the model climb up onto the rock and lean back against it. Her leg was then pulled across her body to cover her groin area for modesty. As you'll notice throughout the book, I do not tend to photograph full frontal nudes with everything showing—it's just not my style. Simply having the model pull her leg across her body eliminates exposure in this area and creates a more tasteful image.

►► LIGHTING

Because it was almost noon when we shot this image, I had the model turn her face toward the sun to open it up and eliminate any harsh or problematic shadows (such as raccoon eyes).

►► COMPOSITION

The top of the pine tree, which shows over the edge of the rock, helps to balance and add another texture to the image. Without it, the expanse of rock could be a little too much. The tree also helps to add character to an area of the frame that would otherwise be flat and gray (since there were no clouds). A rugged border was printed on the shot to match the rugged character of the setting.

CAMERA:
Yashica T-4

LENS:
35mm fixed lens

FILM:
Kodak Tri-X
at ISO 400

Model: Brandi

EXTENSION TUBES

⇨ POSING

This portrait was created in the studio with the model seated at a posing table. The model's head was slightly tilted. This creates diagonal lines that improve the composition. It also creates a more natural look—people rarely hold their heads straight up, after all. Here, the slight tilt also adds a bit of sensuality.

⇨ CLOSE-UP

I used extension tubes to get this extreme close-up. I've always used extension tubes for jewelry and other product shots, but they also work great for portraiture. I use a Pentax kit that comes with three tubes (numbers 1, 2, and 3). I use the shortest tube (number 1) quite often when doing headshots. For this portrait, I got a little closer by using tube number 2. The only drawback with doing a close-up this way is that you need to be almost on top of the model—in this case I shot from roughly three feet away. For a model who isn't uncomfortable with the camera so close, this can be a great technique.

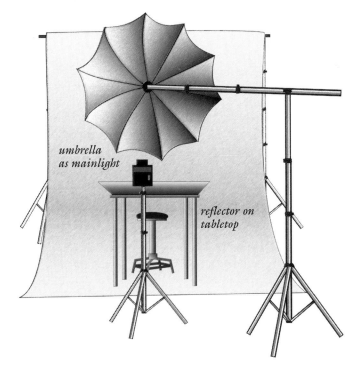

umbrella as mainlight

reflector on tabletop

CAMERA:
Pentax 67

LENS:
165mm, f/2.8, with #2 extension tube

FILM:
Kodak TMAX

⇨ DEPTH OF FIELD

This model has a beautiful face, so I chose to accent just the eyes and lips. To do this, I selected a very shallow depth of field so that only her dark eyes and lips would be in sharp focus, leaving her ear, hair and neck soft and out of focus.

⇨ FILTRATION

A #2 yellow filter was used to achieve good contrast between the model's dark lips and eyes and her pale skin. The eyes and lips are just about the only dark areas in the frame, so this helps call attention to them.

⇨ LIGHTING

An umbrella was used as the mainlight and placed directly over the camera. Since the camera was very close to the model, this also put the light very close and resulted in very soft light with open shadows. A silver reflector was also used on the top of the posing table. It bounces fill light up under her chin and further opens up the shadows.

Model: Kate

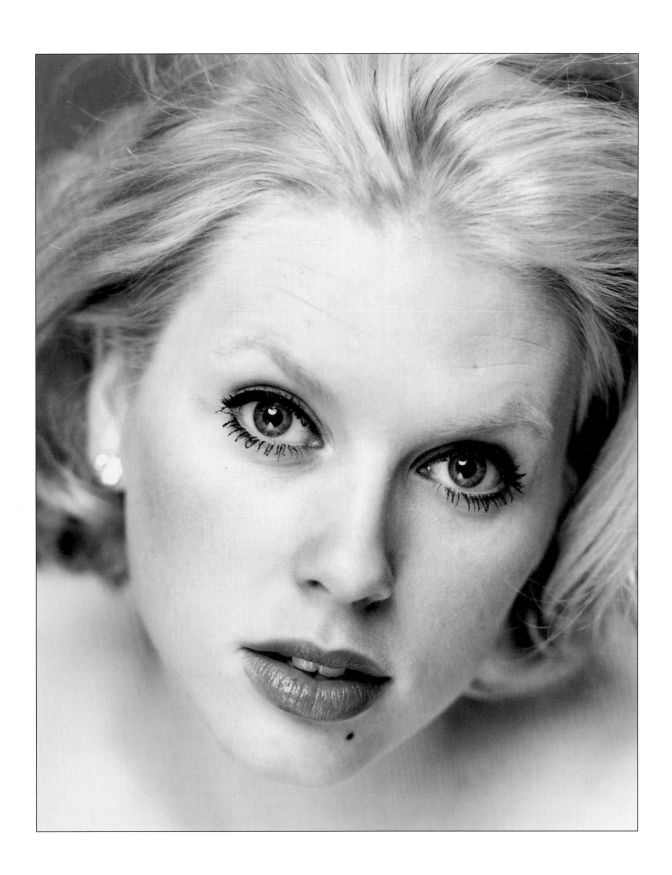

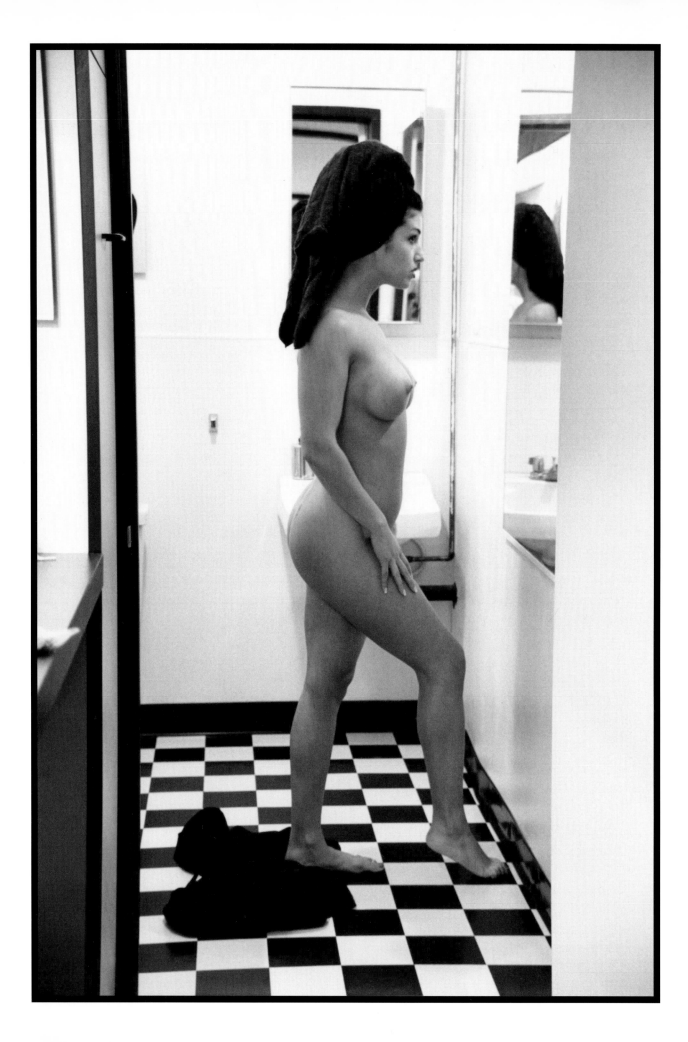

VOYEURISM

SETTING

This image was created in the bathroom of my studio. The model was getting changed and, as many of the models I've worked with, wasn't particularly concerned about privacy. When I saw this moment happening, all that was needed was a little fine-tuning to complete the image. As you can see, the image draws on the sense of voyeurism that is currently experiencing popularity in photography.

CAMERA:
Nikon 8008

LENS:
28–200mm

FILM:
Kodak Tri-X

COMPOSITION

This is a very graphic composition with strong lines throughout the frame. The most obvious lines are in the great checked floor, where the black and white tiles lead you into the room and toward the model's body. To either side of the model, strong vertical lines also bounce your eyes back from the edges of the frame to the focal point—the model.

POSING

The model simply stood looking into the mirror. The leg closest to the camera was raised slightly to add a little motion to the photograph, and also to conceal the groin area. In addition to providing a bit of coverage, the stance also adds a sense that she is stepping forward out of her robe, which lies behind her on the floor.

LIGHTING

The mainlight for the image was placed on top of a bookcase, just inside the door to the bathroom. I did this so that the light source wouldn't show in the photograph. The light was triggered by remote, and bounced up off the ceiling. The result looks almost like an overhead light.

Model: Marjorie

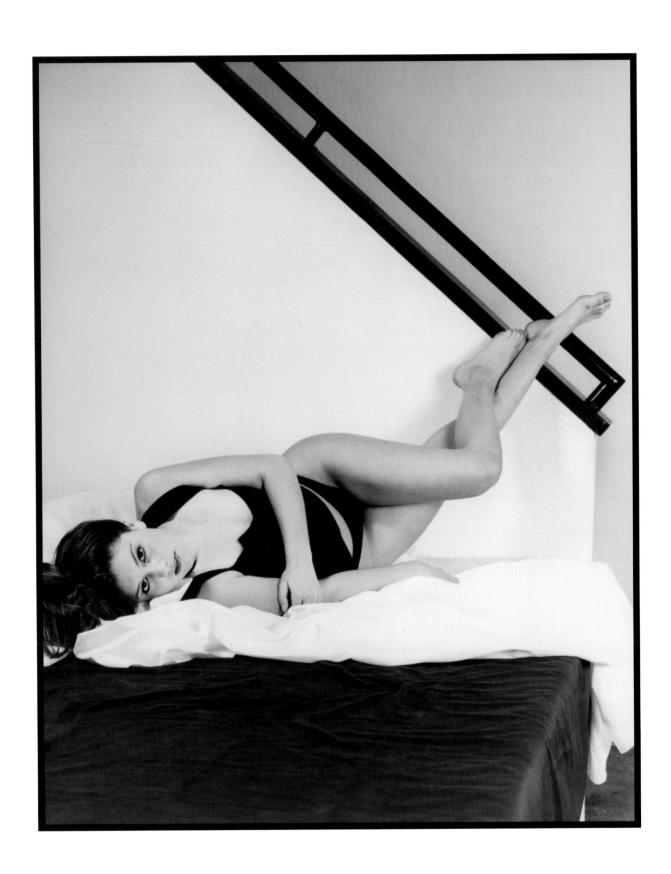

LEGS

⇢ SETTING

We created this image in the studio, next to the staircase that leads to the second floor. It's the same location where the photograph on page 6 was shot.

⇢ POSING

This model has great legs, so I wanted to show them off in her photographs. For this one, she was posed lying down on a wooden platform. The platform was covered with a black sheet (then a white sheet over it) to make it look as though she was lying in bed. The model then kicked her legs up on the wall in this very graceful and feminine pose, with one knee slightly bent. Her left elbow was also bent at a similar angle to that of her knee, helping to tie the pose together compositionally.

CAMERA:
Pentax 67

LENS:
165mm, f/2.8

FILM:
Agfapan 100

⇢ EXPRESSION

Since she also has a beautiful face, I asked her to look into the camera. Her dark eyes and dark hair perfectly match the moody, direct expression on her face.

⇢ LIGHTING

A single softbox, placed to the right of the camera, was used to create smooth, even lighting across the model's body.

⇢ CLOTHING SELECTION

Since the model is posed on top of a white sheet and in front of a white wall, having her wear black helps to separate her from the light tones that surround her.

⇢ COMPOSITION

Diagonal lines are a strong element in any composition. Here, two strong diagonals form the core elements of the image. The first line is created by the model's body which, with her lifted legs, cuts at an angle across the frame. The line of her body meets with the diagonal stair railing, the second strong line, near the frame's edge. Mirroring each other, these lines form the central elements of the composition.

Model: Lindsay

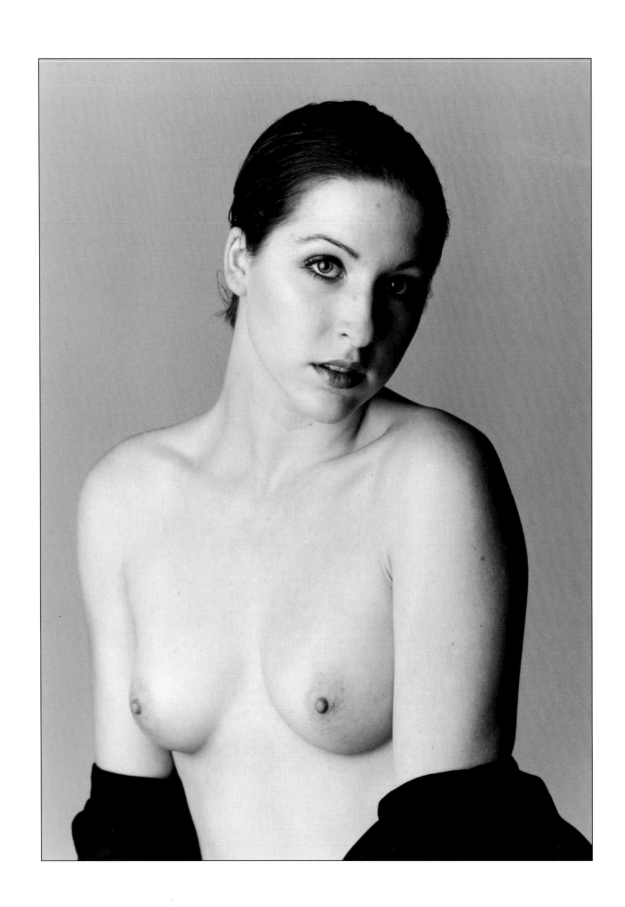

SIMPLICITY

➤ ATTITUDE

This portrait pairs a great face with a dramatic, slicked-back hairstyle. The result is a dramatic and flattering image with a little bit of attitude. While still very feminine, this model looks like she has a little edge.

➤ POSING

To create this image, the model was seated on a posing stool in front of a gray seamless paper backdrop. It's a simple setup that keeps the focus on the model.

➤ LIGHTING

The light here is also very simple. A single softbox was used to the left of the camera. The result is even lighting across the front of her face and body, but with deep, dramatic shadows on the far side. While a hair light could easily be added to this setup for another look, it was not used here, since I wanted to keep her hair dark and dramatic.

CAMERA:
Pentax 67

LENS:
165mm, f/2.8

FILM:
Agfapan 100

➤ COMPOSITION

When doing a waist-length shot like this, it often helps to provide some area of interest toward the bottom of the frame. In this case, the model had with her a dark jacket. She put it on, then allowed it to fall off her shoulders and collect around her elbows. The result is two dark areas that form the base of a compositional triangle. At the peak of this dark triangle is the model's face and hair. This triangular composition helps move the viewer's eyes around the frame, from the model's face, to her body and back again.

Model: Nicole

softbox as mainlight

⤐ DRAMA

As I've mentioned, the starting point for most of my images is the models themselves. This model's deep brown eyes, full lips and dark, curly hair begged for a shot that was dramatic. This image was the result of that basic idea.

⤐ LIGHTING

Another simple setup, this photograph was created using only one light. In this case, I wanted stronger contrast and crisper shadows than a softbox would provide. Instead, I used a strobe with a grid attachment. The light was placed close to the wall on camera right so the light skimmed across the wall and picked up the texture in the stucco, while creating deep, crisp shadows on the model's face and body. While softer light is often considered more flattering

because it tends to smooth the skin's texture, that is not a problem here. Because the model's face is turned most of the way into the light, the light is very frontal and even where it counts most.

⤐ POSING

The model was posed leaning into a corner in the studio. On the left side of the frame you can see a barn board wall, while a stucco wall shows on the right. A strand of her dark, curly hair was pulled across her neck to add a little sense of movement to the photograph, and also to better frame her face. The model's body was placed in a $^3/_4$ view to the camera. This is a very slimming and flattering perspective that reduces the apparent width of the shoulders and upper body, while still revealing the chest in a flattering manner.

⤐ COMPOSITION

To add some interest to the lower part of the frame, the model's arms were folded. Her arms and uplifted fingers create a compositional area of interest that draws your eye down her body from her face, but retains your gaze within the frame.

Model: Marjorie

CAMERA:
Nikon FM

LENS:
28–200mm

FILM:
Kodak Tri-X

grid spot as mainlight

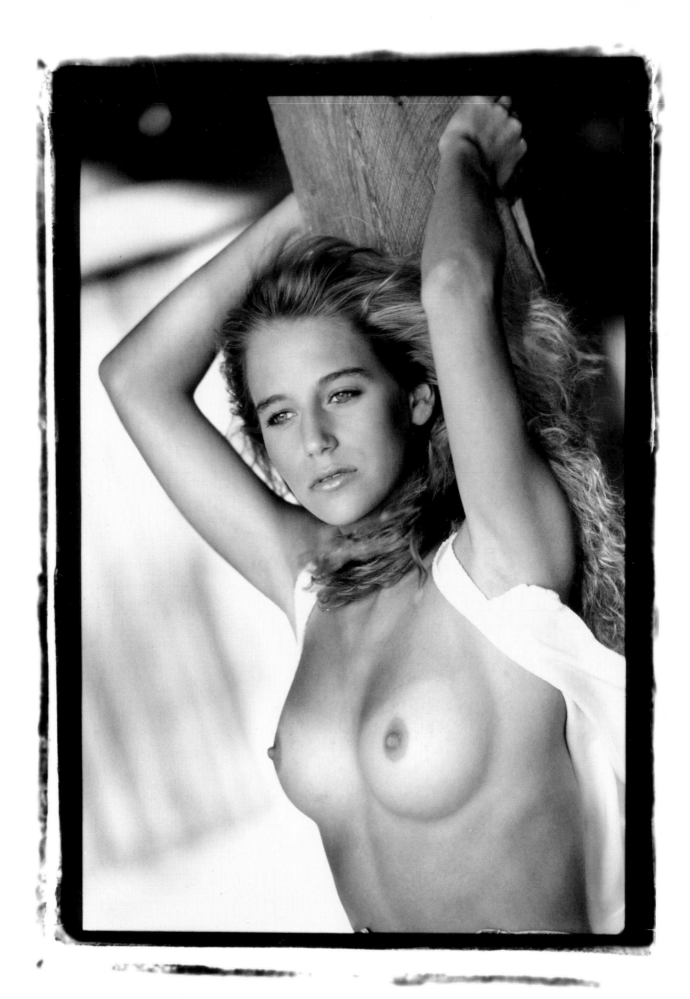

VARIATIONS

⬦ NATURAL LIGHT

The soft, even quality of the model's skin in the photograph shows you just how flattering natural sunlight can be when you find the right modifier. In this case, the modifier happens to be a barn. Because we worked inside the barn in front of two large, open doors, the already flattering northern light took on a beautiful directional quality. With little overhead light to worry about, we worked extensively with this light alone, using no fill of any kind.

⬦ CONTACT SHEET

Looking at the contact sheet to the right, you can see many of the subtly varying poses we tried. Almost all of them work very well, but the one shown on the facing page is my favorite from the shoot.

⬦ CLOTHING

We tried variations of the same pose using two different tops. One was a plain white tank top, the other was white tank top that buttoned down the front. I love the clean, classic look of white tank tops, and the image would have been good with either top (or even without it). But, as you can see in the selected image, the open button-down top helped to create effective definition between the model and the wood behind her. If you look at the right-hand row of photos on the contact sheet, you can see that the model's skin tone is very close to the tonality of the beam.

Adding a white area between the two adds definition.

⬦ CAMERA TILT

I very often like to tilt the camera slightly. This helps turn naturally vertical lines into more interesting diagonal lines, often improving compositions and adding just a bit more interest to the photograph itself.

Model: Kirsten H.

CAMERA:
Nikon F3

LENS:
80–200mm

FILM:
Kodak Panox 32

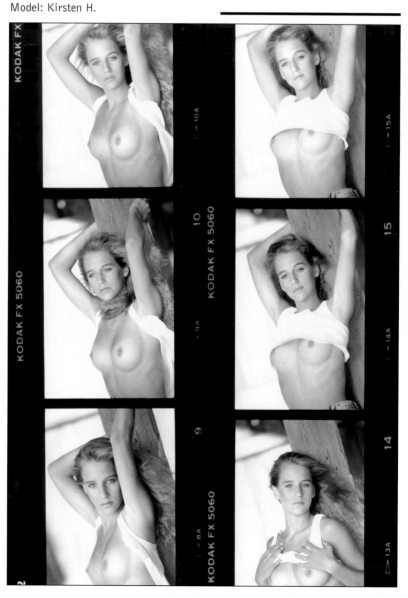

DIAGONALS

⟶ POSING

This model was posed on a platform with her body turned at a 90° angle from the camera. To bring her long legs into the frame, she drew her knees up. Both legs are visible, because her knees were bent at different angles. With her hair draped over one shoulder, the model then turned to face the camera straight on. The result is a flattering profile of her body, which shows off her legs and breasts, with an engaging, full-on image of her face.

⟶ LIGHTING

Three lights were used to create this photograph. To create soft, even lighting on her body, two softboxes were place on either side of the camera. Because her blonde hair played an important role in the frame, an umbrella was used above her as a hair light to add highlights and texture.

⟶ COMPOSITION

Diagonals make for an interesting composition, and this frame is full of them. The model's pose creates a triangle in the frame, with its peak at her face—a primary area of interest. Her legs and arms form additional diagonals that draw your eyes up and down through the frame.

⟶ TATTOO

This model has three tattoos. While I'd ultimately prefer that they weren't there, I never let them become an obstacle to creating a strong image with a model. This type of body adornment is extremely common, so I've learned to live with it. After all, *Playboy* doesn't mind small tattoos on its models. In most cases, if they really bother you, you can find a way to create an image where the tattoo isn't visible.

Model: Michelle

CAMERA:
Hasselblad 500

LENS:
150mm

FILM:
Kodak 400CN

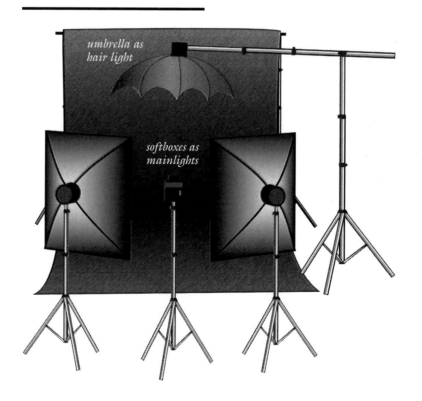

umbrella as hair light

softboxes as mainlights

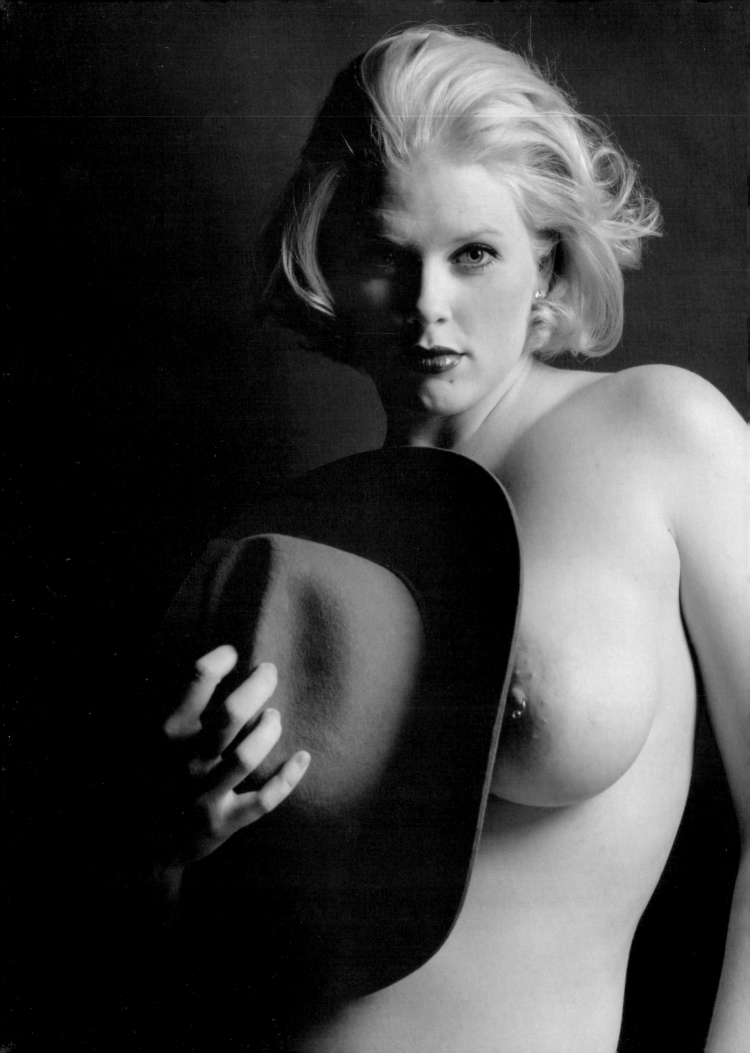

LISTENING

◆ LIGHTING

One softbox, placed to the right of the camera, was used to create this strong, directional lighting. This also highlights her blonde hair, and is soft enough to be flattering on her face and body. Because only half of her body is illuminated, it is also a very slimming setup.

◆ POSING

The model happened to bring this western-style hat with her to the shoot. Because she was uncomfortable with being totally bare, we used the hat for partial coverage.

◆ WORKING WITH MODELS

When working with your subject, you need to keep your ears open and listen to what she has to say about herself and the kind of images she wants to do. Most people are self-conscious about some part of their body. With women, it's usually the hips and thighs. If you do identify a perceived problem area, you need to take steps to minimize the appearance of the problem. With careful lighting and posing, most minor problems or inse-

CAMERA:
Pentax 67

LENS:
165mm, f/2.8

FILM:
Kodak TMAX

curities can be addressed with relative ease. Be delicate and tactful about it, of course. Your goal is to make your model feel comfortable and confident, and to produce images that depict her in the way she wants to see herself.

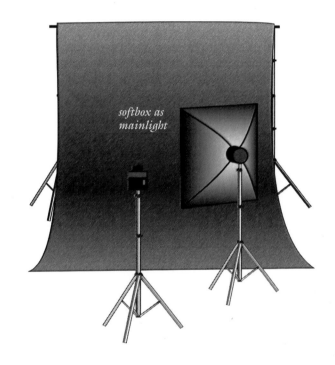

softbox as mainlight

◆ CLOTHING

The model for this photograph wasn't comfortable with total nudity, so she actually wore jeans for the shoot. When we made the final prints, the jeans were simply cropped out of the frame. This was at the model's request, because she felt they drew attention to her hips and made them look a little too full.

Model: Kate

PLANNING

SETTING

This portrait was taken in my studio during a shoot for some images for the model's portfolio. The model was posed on top of a raised platform. A painted backdrop runs down the wall and was pulled out across this platform.

LIGHTING

A 22" silver umbrella was used over the model as a hair light. This makes her curly blond hair sparkle beautifully. The mainlight was a 42" white umbrella placed above the camera. This creates the well-defined catchlight in the upper center of her eye. Finally, a silver reflector was angled towards her from the edge of the platform. This adds fill light to open up the shadows.

POSING

The model, who is experienced at posing for the camera, came up with this soft and feminine pose. We tried many variations of it during the course of the shoot.

CLOTHING

While it may look more formal, the dress the model is wearing is actually a very versatile knit garment—a tube that can be worn a number of ways. We tried many variations with it during the shoot, using it for both clothed and semi-nude images.

WORKING WITH MODELS

I begin formulating ideas for a shoot as soon as I meet the

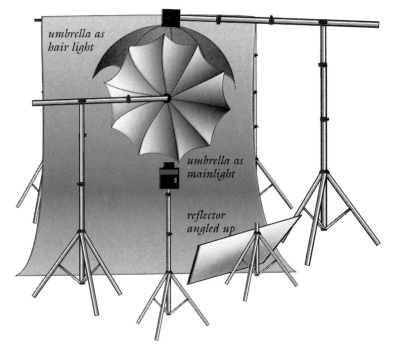

umbrella as hair light

umbrella as mainlight

reflector angled up

model. She may strike me as dramatic looking, or very feminine, or I may notice she has gorgeous eyes. With these impressions in mind, I try to develop concepts based on emphasizing the model's best and most interesting qualities. It's important to have a few good ideas in mind when you walk into a shoot—but not to be too locked into them. Your ideas should serve as a starting point for working with the model, not as a hard and fast rule. The preplanned ideas rarely work out exactly as you expect, but serve as the first step in finding ideas that ultimately *do* work.

Model: Dale

CAMERA:
Pentax 67

LENS:
165mm, f/2.8

FILM:
Kodak Plus-X
at ISO 100

FLAT LIGHTING

CAMERA:
Pentax 67

LENS:
135mm, f/4

FILM:
Agfapan 100

⇢ CONCEPT
After the shoot during which the image of five women (page 6) was created, I asked these two models if they'd like to work on this image. My basic concept was to pair a blonde and a brunette for a waist-up image. This photograph is the result.

⇢ LIGHTING
A 4'x6' softbox was placed directly over the camera as the mainlight. This large, frontal light source creates soft, open shadows for the smoothest possible look on the skin. I prefer this flat lighting for most of my portraits of women, as I find it to be much more complimentary than ratio lighting. The other light used for this shot was a small softbox, positioned over the models as a hair light.

⇢ POSING
The models were each seated on the floor against a black backdrop. They simply leaned in close to one another until their cheeks were touching.

⇢ COMPOSITION
I cropped this image tight, to focus in on just the models' breasts and faces. I did, however, leave just enough of their arms at the edges of the frame to create leading lines up to their faces and eyes, which really tell the story.

⇢ ENDURANCE
On an individual basis, you should plan out your shoot to take into account that most models can't pose for hours without becoming (and looking) tired. While professional models may be able to work for extended periods of time, for most nonprofessionals, being in front of the camera is a draining experience. Once the model is tired or losing her enthusiasm, you won't get the quality of images that you want. That's when it's time to call it a day.

Models: Summer and Nicole

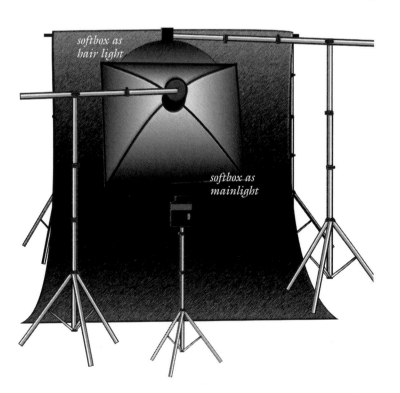

softbox as hair light

softbox as mainlight

COMFORT

➡ LOCATION

Believe it or not, this tropical-looking location is actually a large stand of cattails in a drainage ditch. It just goes to show you the possibilities that abound all around you.

➡ LIGHTING

We created these two images on an overcast day, using only natural lighting. Shooting late in the day provided a low sun angle for nice directional lighting. I simply posed the model facing into the light.

➡ VARIATIONS

The two images shown here illustrate how easy it can be to achieve variety—without a lot of different setups or clothing changes. Dropping the strap of her dress off one shoulder, raising or lowering her arms, opening or closing her eyes— all of these minor changes can be used quickly and simply to add variety to your images.

➡ COMFORT

From start to finish on a shoot, I make sure my models are comfortable—that they have everything they need and know that I don't want them to do anything they aren't sure about. I ask them from the start, "Are you comfortable doing semi-nude images?" "Are you comfortable doing nude images?" I also make it clear that, if I ask them to do anything during the shoot that they don't feel comfortable with, they should simply say so. I don't want my models to simply go along with something that doesn't feel right to them just because they think I expect it. This is especially important to emphasize with models who don't have a lot of experience in front of the camera and may be tempted to just go along with the photographer despite their own feelings. I let models know that I'm not going to be upset if they veto one of my ideas—instead, we'll just do a different image that they feel more comfortable with. Models want great pictures from the shoot, but these great pictures won't happen if the model isn't completely comfortable.

Model: Nicole

CAMERA:
Nikon N90S

LENS:
28–200mm

FILM:
Kodak Tri-X
at ISO 200

H A N D S

the photos on page 118 were shot.

➡ LOCATION

This portrait was created in a small overgrown area on a rise only a few feet away from the ditch where the photos on page 118 were shot.

➡ LIGHTING

The light was very bright and intense, so we moved into a shaded area for a more flattering, even effect. As you can see, the background (which is nothing but sky) is very hot in the photo. This bothers me a little bit, but I think the image is worth it. There are times when you just have to make that call and decide whether the sacrifices are too costly. Here, I loved the light on her and was willing to sacrifice the background.

➡ POSING

As we refined this pose, I shot a few Polaroids and loved the look. However, I thought the underwear was a little too obtrusive. It created a strong horizontal line at her hips that seemed to cut her body in half. To rectify this, I had the model hook her thumb through the underwear and pull it down slightly at one side. This turned a distracting horizontal line into a much more flattering diagonal. The effect lengthens her torso and gives you more of an idea of what her body looks like.

➡ LEGS

My personal guideline for posing legs is to have the model bend the leg that is closest to the camera. This creates a natural, feminine look with a long, pleasing line. By bending the knee across the body, it can also conceal the groin area for a more modest look.

➡ HANDS

This portrait is a great example of the look to strive for when posing hands. Both of the model's hands look graceful and relaxed. They fall naturally on her hips, with her fingertips curled gently to follow the line of her legs. In addition, her nails are well manicured and relatively short with only clear polish—appropriate for the natural setting.

CAMERA:
Pentax 6x7

LENS:
135mm, f/4

FILM:
Agfapan 100

Model: Summer

INDEX

Other Books from
Amherst Media™

Wedding Photographer's Handbook

Robert and Sheila Hurth

A complete step-by-step guide to succeeding in the world of wedding photography. Packed with shooting tips, equipment lists, must-get photo lists, business strategies, and much more! $24.95 list, 8½x11, 176p, index, 100 b&w and color photos, diagrams, order no. 1485.

Lighting for People Photography, *2nd Edition*

Stephen Crain

The up-to-date guide to lighting. Includes: set-ups, equipment information, strobe and natural lighting, and much more! Features diagrams, illustrations, and exercises for practicing the techniques discussed in each chapter. $29.95 list, 8½x11, 120p, 80 b&w and color photos, glossary, index, order no. 1296.

Outdoor and Location Portrait Photography

Jeff Smith

Learn how to work with natural light, select locations, and make clients look their best. Step-by-step discussions and helpful illustrations teach you the techniques you need to shoot outdoor portraits like a pro! $29.95 list, 8½x11, 128p, 60+ b&w and color photos, index, order no. 1632.

Infrared Landscape Photography

Todd Damiano

Landscapes shot with infrared can become breathtaking and ghostly images. The author analyzes over fifty of his most compelling photographs to teach you the techniques you need to capture landscapes with infrared. $29.95 list, 8½x11, 120p, 60 b&w photos, index, order no. 1636.

Wedding Photography: Creative Techniques for Lighting and Posing, *2nd Edition*

Rick Ferro

Creative techniques for lighting and posing wedding portraits that will set your work apart from the competition. Covers every phase of wedding photography. $29.95 list, 8½x11, 128p, full color photos, index, order no. 1649.

Professional Secrets of Advertising Photography

Paul Markow

No-nonsense information for those interested in the business of advertising photography. Includes: how to catch the attention of art directors, make the best bid, and produce the high-quality images your clients demand. $29.95 list, 8½x11, 128p, 80 photos, index, order no. 1638.

Lighting Techniques for Photographers

Norman Kerr

This book teaches you to predict the effects of light in the final image. It covers the interplay of light qualities, as well as color compensation and manipulation of light and shadow. $29.95 list, 8½x11, 120p, 150+ color and b&w photos, index, order no. 1564.

Infrared Photography Handbook

Laurie White

Covers black and white infrared photography: focus, lenses, film loading, film speed rating, batch testing, paper stocks, and filters. Black & white photos illustrate how IR film reacts. $29.95 list, 8½x11, 104p, 50 b&w photos, charts & diagrams, order no. 1419.

Infrared Nude Photography

Joseph Paduano

A stunning collection of images with how-to text that teaches how to shoot the infrared nude. Shot on location in natural settings, including the Grand Canyon, Bryce Canyon and the New Jersey Shore. $29.95 list, 8½x11, 96p, over 50 photos, order no. 1080.

How to Shoot and Sell Sports Photography

David Arndt

A step-by-step guide for amateur photographers, photojournalism students and journalists seeking to develop the skills and knowledge necessary for success in the demanding field of sports photography. $29.95 list, 8½x11, 120p, 111 photos, index, order no. 1631.

How to Operate a Successful Photo Portrait Studio

John Giolas

Combines photographic techniques with practical business information to create a complete guide book for anyone interested in developing a portrait photography business (or improving an existing business). $29.95 list, 8½x11, 120p, 120 photos, index, order no. 1579.

Fashion Model Photography

Billy Pegram

For the photographer interested in shooting commercial model assignments, or working with models to create portfolios. Includes techniques for dramatic composition, posing, selection of clothing, and more! $29.95 list, 8½x11, 120p, 58 photos, index, order no. 1640.

Computer Photography Handbook

Rob Sheppard

Learn to make the most of your photographs using computer technology! From creating images with digital cameras, to scanning prints and negatives, to manipulating images, you'll learn all the basics of digital imaging. $29.95 list, 8½x11, 128p, 150+ photos, index, order no. 1560.

Achieving the Ultimate Image

Ernst Wildi

Ernst Wildi teaches the techniques required to take world class, technically flawless photos. Features: exposure, metering, the Zone System, composition, evaluating an image, and more! $29.95 list, 8½x11, 128p, 120 b&w and color photos, index, order no. 1628.

Black & White Portrait Photography

Helen T. Boursier

Make money with b&w portrait photography. Learn from top b&w shooters! Studio and location techniques, with tips on preparing your subjects, selecting settings and wardrobe, lab techniques, and more! $29.95 list, 8½x11, 128p, 130+ photos, index, order no. 1626

Black & White Model Photography

Bill Lemon

Create dramatic sensual images of nude and lingerie models. Explore lighting, setting, equipment use, posing and composition with the author's discussion of 60 unique images. $29.95 list, 8½x11, 128p, 60 b&w photos and illustrations, index, order no. 1577.

Profitable Portrait Photography

Roger Berg

A step-by-step guide to making money in portrait photography. Combines information on portrait photography with detailed business plans to form a comprehensive manual for starting or improving your business. $29.95 list, 81/2x11, 104p, 100 photos, index, order no. 1570

Handcoloring Photographs Step-by-Step

Sandra Laird & Carey Chambers

Learn to handcolor photographs step-by-step with the new standard in handcoloring reference books. Covers a variety of coloring media and techniques with plenty of colorful photographic examples. $29.95 list, 8½x11, 112p, 100+ color and b&w photos, order no. 1543.

Special Effects Photography Handbook

Elinor Stecker-Orel

Create magic on film with special effects! Little or no additional equipment required, use things you probably have around the house. Step-by-step instructions guide you through each effect. $29.95 list, 8½x11, 112p, 80+ color and b&w photos, index, glossary, order no. 1614.

McBroom's Camera Bluebook, *6th Edition*

Mike McBroom

Comprehensive and fully illustrated, with price information on: 35mm, digital, APS, underwater, medium & large format cameras, exposure meters, strobes and accessories. Pricing info based on equipment condition. A must for any camera buyer, dealer, or collector! $29.95 list, 8½x11, 336p, 275+ photos, order no. 1553.

Swimsuit Model Photography

Cliff Hollenbeck

The complete guide to the business of swimsuit model photography. Includes: finding and working with models, selecting equipment, posing, using props and backgrounds, and more! $29.95 list, 8½x11, 112p, over 100 b&w and color photos, index, order no. 1605.

Glamour Nude Photography, *revised*

Robert and Sheila Hurth

Create stunning nude images! The Hurths guide you through selecting models, choosing locations, lighting, and shooting techniques. Includes: posing, equipment, makeup and hair styles, and more! $29.95 list, 8½x11, 128p, over 100 b&w and color photos, index, order no. 1499.

Fine Art Portrait Photography

Oscar Lozoya

The author examines a selection of his best photographs, and provides detailed technical information about how he created each. Lighting diagrams accompany each photograph. $29.95 list, 8½x11, 128p, 58 photos, index, order no. 1630.

Black & White Nude Photography

Stan Trampe

This book teaches the essentials for beginning fine art nude photography. Includes info on finding your first model, selecting equipment, and scenarios of a typical shoot, plus more! Includes 60 photos taken with b&w and infrared films. $24.95 list, 8½x11, 112p, index, order no. 1592.

The Art of Infrared Photography, *4th Edition*

Joe Paduano

A practical guide to the art of infrared photography. Tells what to expect and how to control results. Includes: anticipating effects, color infrared, digital infrared, using filters, focusing, developing, printing, handcoloring, toning, and more! $29.95 list, 8½x11, 112p, 70 photos, order no. 1052

The Art of Portrait Photography

Michael Grecco

Michael Grecco reveals the secrets behind his dramatic portraits which have appeared in magazines such as *Rolling Stone* and *Entertainment Weekly*. Includes: lighting, posing, creative development, and more! $29.95 list, 8½x11, 128p, 60 photos, order no. 1651.

Creative Techniques for Nude Photography

Christopher Grey

Create dramatic fine art portraits of the human figure in black & white. Features studio techniques for posing, lighting, working with models, creative props and backdrops. Also includes ideas for shooting outdoors. $29.95 list, 8½x11, 128p, 60 incredible b&w photos, order no. 1655.

Photographer's Guide to Shooting Model & Actor Portfolios

CJ Elfont, Edna Elfont and Alan Lowy

Learn to create outstanding images for actors and models looking for work in fashion, theater, television, or the big screen. Includes the business, photographic and professional information you need to succeed! $29.95 list, 8½x11, 128p, 100 photos, order no. 1659.

Classic Nude Photography: Techniques and Images

Peter Gowland and Alice Gowland

Gowland offers the kind of technical and practical advice that fifty years of experience have to offer. Fully illustrated, this book is a visual tribute to one of the most prolific and highy regarded photographers in the genre of nude photography. $29.95 list, 8½x11, 128p, 60 photos, order no. 1710.

Portrait Photographer's Handbook

Bill Hurter

Bill Hurter has compiled a step-by-step guide to portraiture that easily leads the reader through all phases of portrait photography. This book will be an asset to experienced photographers and beginners alike. $29.95 list, 8½x11, 128p, full color, 60 photos, order no. 1708.